IMAGES
of America

IRANIANS

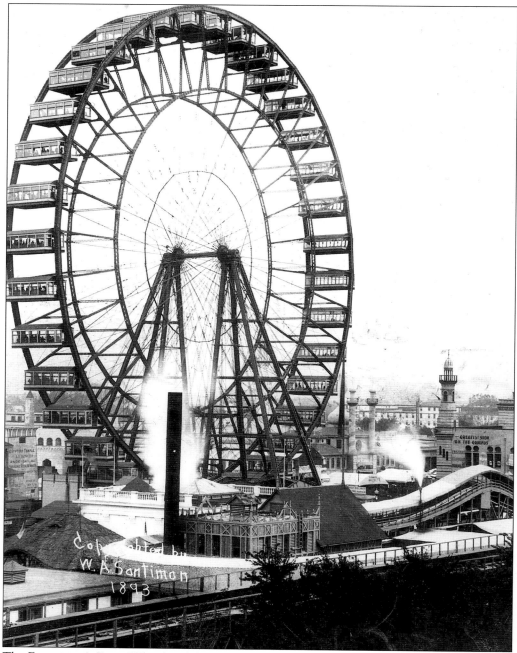

The Exposition's Ferris Wheel and the Persian Palace are pictured here. As Moen-Ol Saltaneh approached Chicago, the Ferris Wheel of the Exposition was one of the first things he saw. A few days later, he visited the Persian Palace, right next to it. (Image by W.A. Sanimon. Courtesy of Chicago Historical Society, World Columbian Exposition 1893 Files.)

(*cover photograph*) The front cover shows the Persian Palace at the Columbian Exposition of 1893. (Courtesy of the Chicago Public Library. Special Collections and Preservation Division.)

IMAGES
of America

IRANIANS
IN CHICAGOLAND

Hamid Akbari and Azar Khounani

ARCADIA

Published by Arcadia Publishing
Charleston SC, Chicago IL, Portsmouth NH, San Francisco CA

Printed in Great Britain

Library of Congress Catalog Card Number: 2004118164

For all general information contact Arcadia Publishing at:
Telephone 843-853-2070
Fax 843-853-0044
E-mail sales@arcadiapublishing.com
For customer service and orders:
Toll-Free 1-888-313-2665

Visit us on the internet at http://www.arcadiapublishing.com

This book is dedicated to our children Azadeh and Kaveh and all other children of Iranian immigrants to the United States.

One hundred and three years after Moen-Ol Saltaneh's first view of the Ferris Wheel and Chicago, another Persian, Amir Noormandi, captures another view of the city, in 1986. This picture is among the images in the Scenes of Chicago catalogue. (Courtesy of d'Last Studios.)

CONTENTS

ACKNOWLEDGMENTS

This book would have not been possible without the help and support of many individuals and organizations in the Iranian community. We owe a big gratitude to every member of the community who supported this project by sharing their stories and personal pictures with us. There are a few that we need to acknowledge more directly. Our dear and beloved artist friend, Ario Mashayekhi, helped with this project in anyway he could. Among other contributions, he gave selflessly of his time and energy to shoot many images for this book. At heart and mind, we think of him as a co-author. Mr. Amir Noormandi provided us with his invaluable archives of artistic images. He has been a tireless member of the Iranian community for the past two decades and we appreciate him very much. Mr. Ali Babazadeh, a poet, was once again a community ally who we could rely on for this project. He generously gave of his time and resources and pictures for seeing the success of this project. We also wish to express our gratitude to Dr. Mehdi Forough and his son, Professor Cyrus Forough, Dr. Heshmat Moayyad, the Birjandi family, the Eghbali family, the Sohaey family, Ms. Laura Paz, Ms. Shahla Afshar, Mr. Keikhosrow Mobed, Ms. Mehrnaz Saeed-Vafa, and Mr. Sohrab Abtahi for allowing us to have their most invaluable pictures and memories for this book. We are also thankful to the Iranian Cultural Society, Pars Educational and Cultural Society, and Iran House of Greater Chicago for providing us with their pictures.

We want to thank Professor Alice Murata of Northeastern Illinois University for initiating this project with us. We also want to thank Dr. Salme Steinberg and Dr. Murrell Duster, respectively President and Dean of Academic Development at Northeastern Illinois University, for being so supportive of the Iranian community as they have been of others. More special thanks go to the wonderful staff at Chicago Historical Society, Special Collections at Chicago Public Library, and the Oriental Institute of the University of Chicago, especially Mr. Thomas James, for giving us of their knowledge and expertise in finding many impressive pictures for the book. We also owe another big gratitude to Elizabeth Beachy, our editor at Arcadia, and other most wonderful people at Arcadia Publishing. They are truly involved in a historic mission with their publications.

Further we want to thank our children, Azadeh and Kaveh, for always giving us their love, support, and understanding as we have been engaging in these kinds of projects for the past 18 years. We are most thankful to our parents and our sisters and brothers for giving us love and support over the years and giving us the opportunity to live in the United States.

INTRODUCTION

Chicago is a major center for Iranians living in the United States. According to the last census, there are about 6,000 people of Iranian ancestry living in Chicago. However, this number should be looked at as an underestimation—the actual number lies somewhere from 15,000 to 25,000. Besides serving those Iranians who live in the city and in the suburbs, Chicago, with its variety of Iranian community organizations, Persian events, and Persian restaurants and stores, serves as a hub for the larger community of Iranians living in other parts of Illinois and the adjacent states, including Wisconsin, Iowa, Indiana, Kansas, Missouri, Michigan, Minnesota, and Ohio.

According to the latest data, Iranians in the United States are considered among the top three, if not the very top, most-educated immigrants. Education is, indeed, one of the highest held family and community values among Iranians. "Which is better for one: Knowledge or Wealth?" This was the title of an expository essay that every elementary student had to write in school in Iran. And the answer was mostly "knowledge." Among Iranians in Chicago, the resonance of a high value placed on education is well evidenced by the fact that there are so many Iranians with higher education degrees, with many of them working as medical doctors, university professors, teachers, computer specialists, lawyers, architects, and engineers. Chicago is especially known for its high ratio of Iranian medical doctors to the total of number of Iranians living here.

There is not a single center or source of information about Iranians living in Chicago, or, for that matter, the United States. Given this, we need to underscore the fact that we do not consider this book to be a definitive account of the life and history of Iranians in Chicago. Our book rather consists of a select number of images and stories of the lives of many—not all—Iranians in Chicago. In this book, we have collected and recollected what we believe would best represent the Iranian community in Chicago. We are the first to admit that there were, unfortunately, due to the lack of space and other limitations, many people and stories, events, and organizations which are not included in this book. Moreover, there were many people who, for respectable reasons, did not want to provide us with their pictures or stories, at least not at this time. However, we are pleased to present an eclectic assembly of images and stories that show various aspects of immigration, life, and contributions of Iranians living in or visiting Chicago. We regard our work as a small first step and truly encourage others and hope that they will follow this up with their work.

Two important notes must be made with regard to the limited scope of this book. First, this book does not in any distinct way or through details cover and capture the stories and images of any religious or ethnic minority group of Iranians, such as Bahai'is, Assyrians, or Jews in Chicago. Our book is limited to the presentation of the images and stories of those who predominantly identify themselves as Iranian. Furthermore, in the Arcadia Images of America series, there is already a book called *Assyrians in Chicago*, which includes detailed coverage of Iranian Assyrians in Chicago. Second, we wish to make it very clear that the existence and the sequence of pictures and stories do not in any way suggest an association or affiliation between people or the stories or conclusions of separate parts of the book.

In short, in preparing this book, we had these goals and hopes: first, we wanted to provide a preliminary source of brief images and stories of the proud community of Iranians living in Chicago to non-Iranians; second, we hope that this book provides Iranian children and youth

living in Chicago and the United States with a compact view of their parents and other ancestors living in Chicago and the United States; and, third, we believe that relating the past activities and achievements of the Iranian community is helpful to the future of Iranians in America. This future, we believe, will be far brighter with the help of the next generation of Iranians and Iranian Americans in Chicago and everywhere in the world.

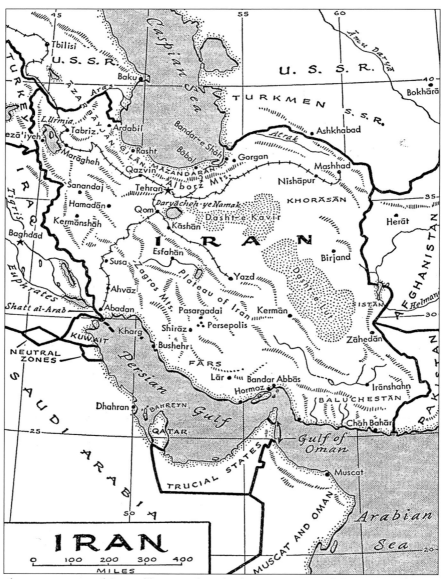

Shown here is a map of Iran. (Reprinted with the permission of Simon & Shuster Adult Publishing Group, from *Iran* by Yahya Armajani. Copyright 1972 by Prentice-Hall, Inc.)

8

One

IRANIAN ROOTS AND THE COLUMBIAN EXPOSITION

Most likely, the first group of Iranians came to Chicago in 1893 as members of the Iranian Exhibition for the renowned World Columbian Exposition. This is recorded by another early Iranian traveler to Chicago, Haj Mirza Mohammad Ali Moen-Ol Saltaneh, in his Chicago Travel Memoir, published in 1903. Moen-Ol Saltaneh's journey, with the main intent of visiting the Columbian Exposition, took more than two years. He departed Iran in 1892 from Bandar Anzali, a Caspian Sea port city, and went through Russia, Ukraine, Austria, Italy, France, and finally England, where he boarded a ship for New York. In London, a translator, Mr. Morad, accompanied him for his trip to the United States and Chicago. Before coming to Chicago, Moen-Ol Saltaneh and Mr. Morad visited New York, Philadephia, and Washington D.C.

Moen-Ol Saltaneh describes his arrival in Chicago on the train in this way:

> [On Monday] we see a number of gigantic factories—including what appears to be a gas factory. Now, the Michigan Lake appears on our right side. At 1:15 p.m. we arrived in a small town five miles away from Chicago. There were many houses, buildings, and streets all around us and there were innumerable railroad tracks scattered all over with wagons either moving or standing. . . . On our west, the Exposition's domes and the big Ferris Wheel are evident. Streets on the city's outskirts have a few buildings and they are so empty that a person thinks nobody lives there. . . . They had to stop the train as we reached a huge river on our way. The bridge was lifted for a ship to pass through. This river connects to the lake and the ships enter the river for carrying the shipments. . . . We arrived at Chicago's Central Train Station. This is a very large station and is located in the city center. From the side of the station to the lake, there are plenty of magnificent buildings. The other side of the station is rather barren and flat. From the station, we took a carriage for Auditorium Hotel, which is the best Chicago Hotel. En route, we passed through long streets. The one we passed through was called Avenue Oubach. A building we passed by was between 12 to 14 stories long. . . .

On a Wednesday, Moen-Ol Saltaneh writes of his visit to Iran's Exhibition, for which we were able to find pictures and stories through our search in Special Collections at the Chicago Historical Society and the Chicago Public Library. He writes:

> The exhibition for Iran is located on the left side of the street. It consists of a green dome with two narrow minarets. Inside the dome are four rooms and a stairway reaches the upper floor, which includes a coffee house. Iranian government has licensed this exhibition to a [Iranian?] Jewish person. A group of Iranians hired by this person worked in the exhibition. In one of the rooms, an Iranian baker makes and sells a variety of Iranian sweets. And other products, such as large and small size carpets, materials and antiques are sold in the other three rooms. In the upper floor, a number of French women dancers . . . wearing Persian dresses and posing as Iranians were dancing for visitors. In the upper level coffee house, a number of Iranians [men] sold Persian tea and coffee. In

the lower level sports salon [zoorkhaneh], a number of Iranian athletes from Azerbaijan
. . . were performing traditional athletic moves with their tools.

After staying in Chicago for 14 days, Moen-Ol Saltaneh and Mr. Morad departed for San Francisco and returned to Chicago after two weeks to further explore the Exposition. They left Chicago for the last time on a Saturday for Niagara Falls and then departed to New York to return to Europe en route to Iran. Moen-Ol Saltaneh writes: "On Thursday, we left Bandar Anzali and entered Rasht [a major city in northern Iran] in our beloved homeland." Thus ended the long journey of one of the first Iranians to Chicago.

Based on other published accounts, there were two other groups of Iranians who came to Chicago in the early years, following Moen-Ol Saltaneh's journey: a large group of Iranian Assyrians, whose account of immigration and settlement is well documented in another book in the Images of America series, *Assyrians in Chicago*, by Vasili Shoumanov; and a group of Iranian Bahai'is, who began arriving in Chicago around 1900 and included the revered Bahai theologian, Abul-Fazael, and Gholam Ali Khan Nabil-Ol Dowleh, his translator and personal caretaker. Nabil-Ol Dowleh, later became Iran's Consul in Washington D.C.

We don't believe that Moen-Ol Saltaneh, who undertook a long, two-year journey to visit Chicago, could have had the slightest inkling that little more than a century after his journey, there would be tens of thousands of Iranians who would travel to Chicago, and that in 2005, there would be at least 10,000 of them calling Chicago home.

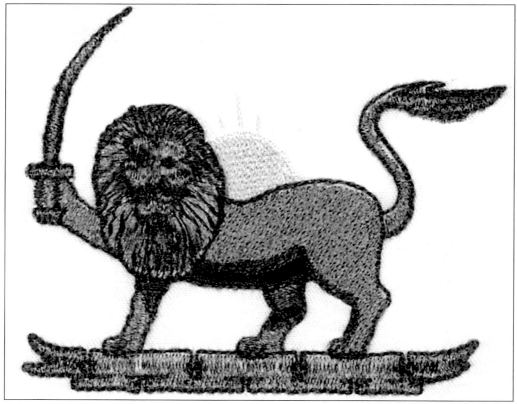

"Lion and Sun,"an ancient emblem of Iran, was featured on the Persian Palace. The Palace is described in the *Portfolio of World's Fair* (Chicago Historical Society): "This structure, a queer mingling of the architectural types of rural, New England, and distant Persia, is styled the 'Persian Palace,' and its national character is indicated by the grinning, unnatural, whiskery-maned lion of the Shahs that prances, sword in Paw, above the palace."

Haj Mirza Mohammad Ali Moen-Ol Saltaneh visited the World Columbian Exposition in Chicago in 1893. This picture, taken in Paris in 1903, was printed in his book *Chicago Travel Memoirs*.

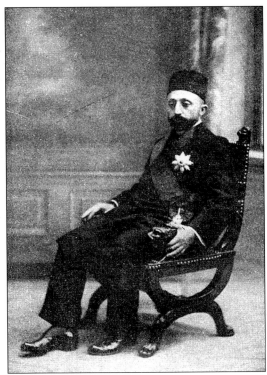

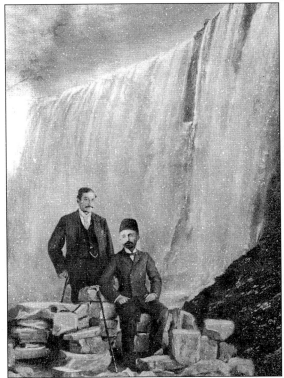

This picture shows Moen-Ol Saltaneh and his translator, Mr. Morad, who accompanied him in the United States and Chicago. This picture was taken at Niagara Falls as the two traveled there following their visit to Chicago in 1893.

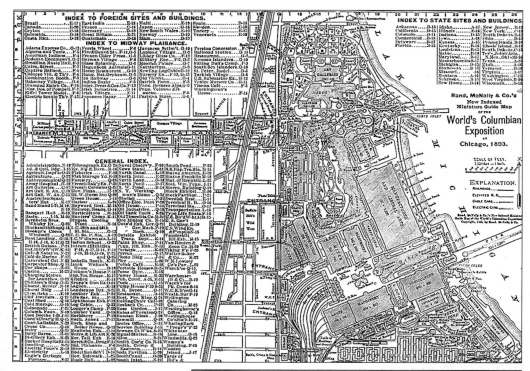

Above is a map of the World's Columbian Exposition. The Persian Palace, indexed as Persian Concessions, is on F7 on Midway Plaisance. Midway Plaisance housed the Exposition's Ferris Wheel and the exhibitions of the other Middle Eastern, African, and Asian Countries and of American Indians (Courtesy of Chicago Historical Society, World Columbian Exposition of 1893 Files.)

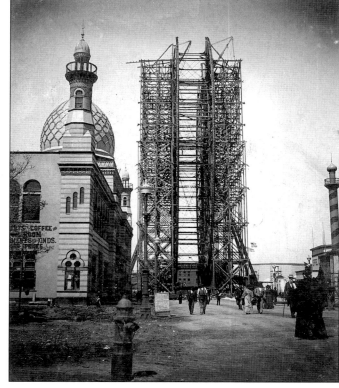

The Persian Palace and the Ferris Wheel are shown here during the construction phase of the Exposition. (Image by W. A. Santimon, 1893. Courtesy of Chicago Historical Society.)

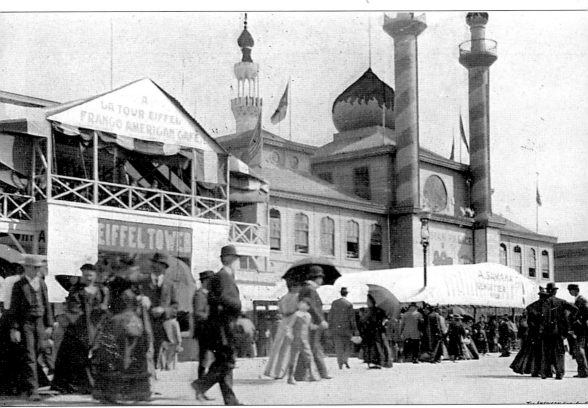

This view of the Persian Palace was captioned "Well-Known Spot" in the Chicago Times, with the following text:

> When going west on the Midway, just before the Ferris Wheel was reached, the traveler came to the corner in which the buildings shown above were situated. It was a wonderfully busy locality, a sort of delta-openings for the masses which moved east and west, and often dividing, passed on different courses around the fenced-in wheel. The picture was so quietly taken that no one had time to pose. Everything is life-like. On the right, in the group of three, the slant of a man's body shows his earnestness of manner. In the center, a small boy has half turned and is looking up at the huge wheel, while on the left the men and women have not had time to drop their uplifted feet. The Eiffel Tower and Persian Palace buildings form a well remembered background, and above their roofs rises the spire of the Mosque in Cairo Street. It is one of the hot days, for the umbrellas are out in full force.

(Courtesy of Chicago Historical Society, Chicago Times Collection.)

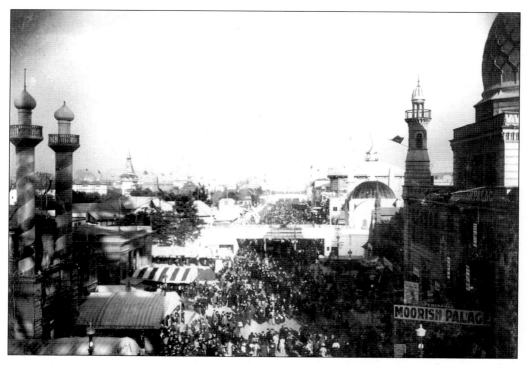

Shown here are two additional views of the Persian Palace. (Courtesy of Chicago Public Library, Delano World Columbian Collection, Special Collections and Preservation Division.)

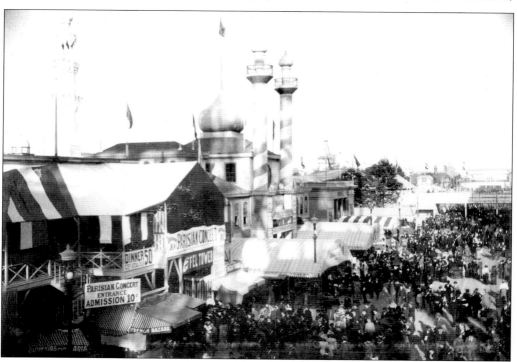

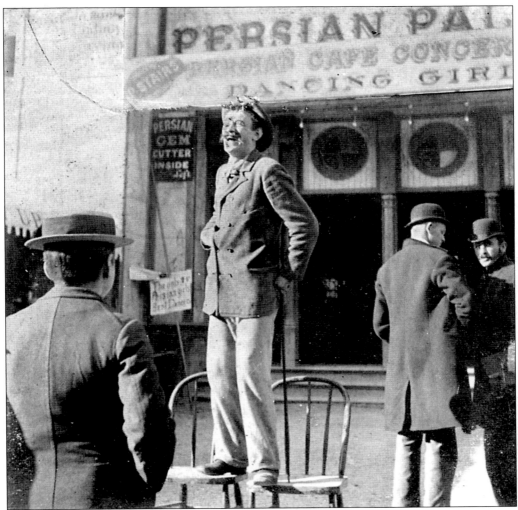

This picture, from the Chicago Times, shows a silent orator in front of the Persian Palace. Here are parts of the original caption:

> Silent Oratory. A special feature of the Midway was its noise, the volume and variety of which first astonished and then pleased the visitor. The street was Babel without a tower. Venders of common and unique wares, criers for places of amusement, uncouth music on uncouth instruments, merchants in the hot kabab (sausage) trade, and traders in Oriental wares, commingled their voices and their trumpets continuously. Never before was there anything like it; probably never will be again. . . . The Fair authorities did not appreciate the situation, nor the cravings of most of the frequenters of the Midway. They issued an edict for silence. They shut up the mouths of these Demosthenes. In reprisal the shop and show men hired pantomimists, who righted by mimicry the wrongs of themselves and the public. These grotesque orators of silence held crowds at bay. The illustrations [only the above shown here] show two of them on their rostrums, and they will be remembered by all who had the luck to see them.

(Courtesy of Chicago Historical Society.)

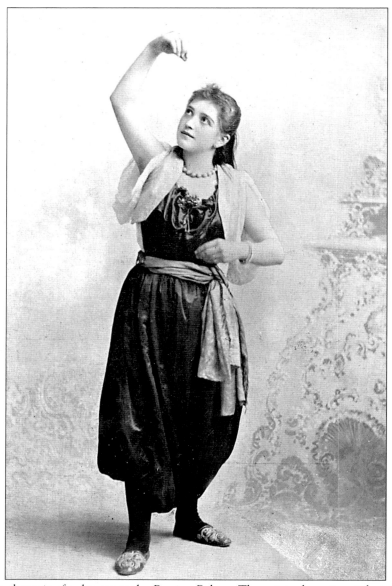

The picture above is of a dancer at the Persian Palace. The original caption title is "A Dancer of the Persian Palace." Moen-Ol Saltaneh writes about the Persian dancers in his book and describes them as French women in Persian clothes. Moen-Ol Saltaneh further writes that the Iranian men were offended by this "barbaric" act of having French women pretend to be Iranian women and were planning to protest it by stopping work and closing down the palace! The authors' research provides some evidence that at least some of the women were indeed French. One such evidence, a descriptive writing from the *Portfolio of the World's Fair* states:

> *The girl is pretty and not more than sixteen years old. Her head is adorned with a gold cap and tassel. She wears a gold and yellow bodice. . . . Her Orientalism has a Parisian flavor. . . . Her dancing has a vivacity that is unusual among her cult, and this Parisian of Tehran. . . .*

(Courtesy of Chicago Historical Society, Chicago Times Collection.)

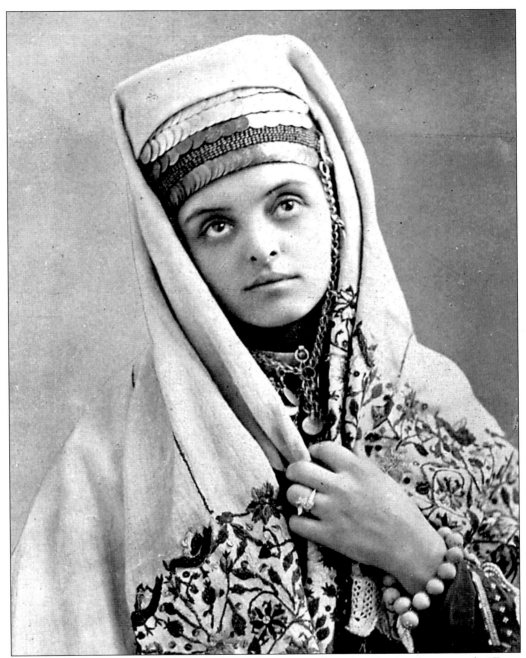

The original Chicago Times caption title for this picture of another Persian dancer reads: "From the Shah's Dominions" and includes this description: "In the drape and pose of the head of this Persian beauty there is a Madonna-like semblance. She was only an unobtrusive woman of the Persian bazaar, yet her features—the large, languishing eyes, large mouth and broad chin—are scarcely those which romance and legends have taught the world to associate with the languishing women of the Shah's dominion." (Courtesy of Chicago Historical Society, Chicago Times Collection.)

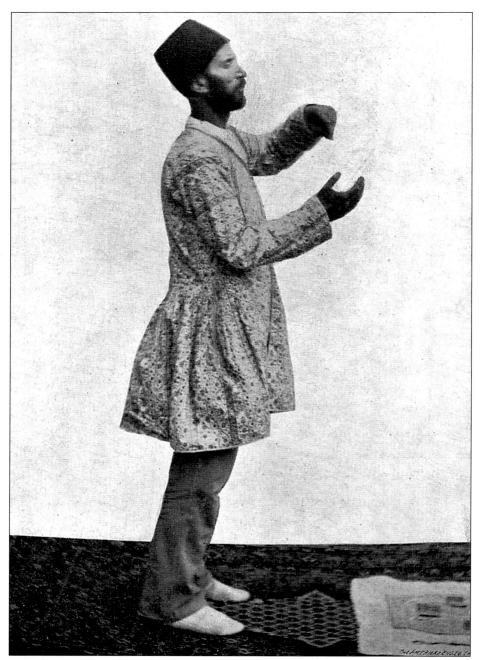

Depicted above is one of the earliest Iranians in Chicago, in1893. Parts of the original caption read:
The Persian at the Exposition was unquestionably lonesome in his religious duties. .
. . The Persian religion of the modern times is Mohammedism [Islam], though there
are about 105,000 Parsees devotees of the very ancient form of Zoroaster, who
existed many hundred years before the coming of Christ, and whose Zend Avesta was
a combination of laws and legends. . . .
(Courtesy of Chicago Historical Society, Chicago Times Collection.)

This is a drawing of a musician and dancers at the Persian Palace. (Courtesy of Chicago Historical Society, Portfolio of the World's Fair.)

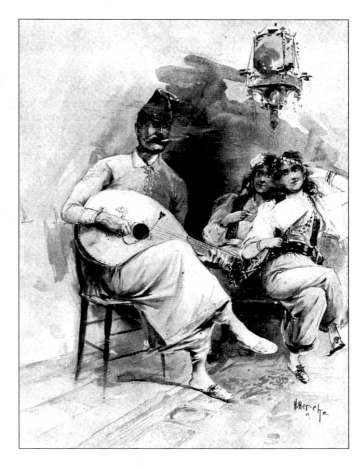

45 North Wabash

Dr. Mokri (no picture) had an Antique Shop on the fifth floor at 45 North Wabash Avenue and was known to many Iranians who came to Chicago in the 1960s and 1970s as a kind and hospitable father figure. According to personal recollections, Dr. Mokri (an eye physician) left Iran with his family in 1930, and after departing Egypt, they arrived first in New York. In the mid-1930s, Mokri came to Chicago and remained here until his death in the early 1980s. After a short time in Chicago, Dr. Mokri became involved in the antique trade and opened his shop. Mr. Kiekhosrow Mobed, a well-respected fellow immigrant, told the authors, "Anytime Dr. Mokri saw an Iranian, he was ecstatic and was most hospitable and helpful to him or her." Mr. Mobed immigrated to Chicago in 1970 (see Chapter Three for his picture).

Pictured here are the first Assyrian immigrants from Iran to be married in Chicago (1909). This 1916 image shows, from left to right: Suria Sayad (mother), Daniel Sayad (father), Sara Sayad (grand mother), Blanche Sayad (girl standing), Samuel Sayad (boy sitting), and Sara Sayad Paz (girl sitting). (Courtesy of Laura Paz.)

Assyrian Choral Society benefit concerts were held to help Assyrians in Iran who were destitute after World War II. This picture shows Balanche Sayad (director) and daughters of Assyrian immigrants from Iran, as well as Assyrian Iranians. (Courtesy of Laura Paz.)

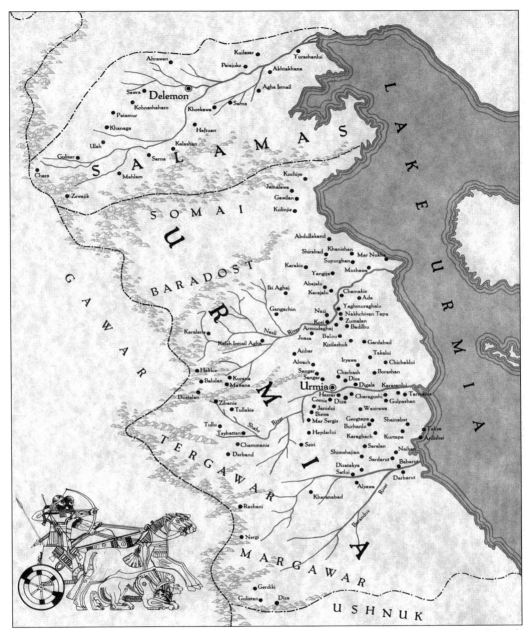

Above is a map of the Assyrians of Iran. Iranian Assyrians, in general, strongly identify with their villages of residence in Iran. Laura Paz remembers the conversations of the Iranian Assyrian elders who would become so excited once they met someone from their village or the adjacent ones from Iran. (Courtesy of Laura Paz.)

Mirza Abul-Fazael (left), the revered Bahai faith grand scholar, and his translator and personal caretaker, Gholam Ali Khan Nabil-Ol Dowleh, came to Chicago in July 1901. Marziah Gail, daughter of Gholam Ali Khan, writes of her father's arrival in Chicago: "A number of believers met Khan's train in Chicago and escorted him to the Bahai house on West Monroe Street, the headquarters here of the Faith." Two months later, Mirza Abul-Fazael arrived in Chicago. Gail writes that Abul-Fazael's "arrival in Chicago created a great stir, not only among Bahai'is and seekers but the general public." Gail quotes his father that Abul-Fazael was "not only a historian . . . of religion, philosophy and world politics, but a 'true philosopher of history.' And his devotion to the Faith of God within every great religion was matched only by his selflessness and his (not typical of scholars) humility." A few years later, Gholam Ali Khan became Iran's Consul in Washington D.C. (Courtesy of Marziah Gail and Dr. Heshmat Moayyed.)

Two

HISTORICAL, CULTURAL, AND ARTISTIC HERITAGE

In 1995, Governor Jim Edgar of Illinois issued a proclamation calling March 21 of 1995 Iranian Heritage Day in Illinois. This historic proclamation was a well-deserved formal recognition of not only Iranian Americans' numerous contributions to Chicago and beyond, but also of the rich presence of Iran's history in the huge collection of Persian archeological objects displayed and kept at the University of Chicago's Oriental Institute. Indeed, the Oriental Institute holds one of the largest collections of ancient Persian archeological findings. Moreover, the University of Chicago Library's Persian section is among the largest Persian libraries in the United States.

Iran is one the few countries, along with Greece, China, India, and Egypt, which has remained in existence as a nation-state since the ancient times. Iranians throughout history have been proud of their ancient Persian heritage. Persia is considered among the first great states that developed effective rules of government as Cyrus the Great first consolidated Iran's rule over a vast territory about 2,500 years ago. His famous charter of the "Freedom of Religion and Nations" upon his entry to Babylon, which resulted in the freedom of the Jews among others, is considered to be one of the fundamental texts of human rights and adorns a part of the United Nations.

A most important aspect of ancient Iran, which has been cherished and kept dearly by Iranians, is Nowrouz, the Iranian New Year. In fact, the 1995 proclamation by Illinois Governor, Jim Edgar gives special recognition to Nowrouz. This beautiful celebration is observed not only by Iranians throughout the world, but also by the people of Afghanistan, Tajikistan, Turkmenistan, Republic of Azerbaijan, and Uzbekistan. Indeed, if there is one event that fully unites Iranians, it is Nowrouz. . This unique non-religious celebration is one every Iranian cherishes greatly. In glorious harmony with nature, Nowrouz portends a new beginning for everything in life. Ancient Iranian culture and life were filled with numerous celebrations, practically monthly, each celebrating a different aspect of life in harmony with nature.

Iranians also cherish their rich poetic and artistic heritage. Poetry is an inseparable part of the Iranian identity. The world-renowned epic and philosopher poets, such as Ferdowsi, Rumi, Hafiz, Saadi, Nezami, and Khayyam are all Iranians. Today, Rumi and Khayyam provide spiritual fulfillment to millions of readers in the West and throughout the world. In Chicago, there are regular poetry gatherings of Iranians, including a monthly poetry night which was founded in the 1980s, and an annual Poetry Night in celebration of Mehergan, another ancient Iranian celebration, in mid-October of each year.

Persian carpets are probably the most well-known artistic creations of Iranians, with which people everywhere in the world are familiar. There are many Persian carpet stores in the Chicago area, owned and operated by Iranians. Beyond carpets, many Iranians have enriched Chicago and beyond with artistic works and productions.

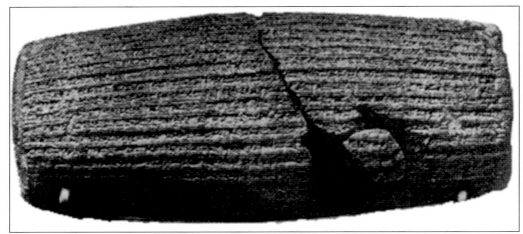

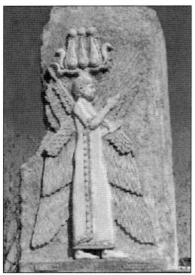

In "A Portrait of Cyrus, King of Persia," Harold Meij H.P. titles this "The Cylinder Seal and Inscription of Cyrus the Great from Babylon." He explains:

> Cyrus, later known as Cyrus the Great, lived from 580–529 B.C., and was the first Achaemenian Emperor of Persia, who issued a decree on his aims and policies, later hailed as his charter of the rights of nations. Inscribed on a clay cylinder, this is known to be the first Declaration of Human Rights, and is now kept at the British Museum. A replica of this is also at the United Nations in New York. He was King of Persia from 559 B.C. until 530 B.C. His mother was the daughter of the Median King Astyages, his father was a vassal to that king. As such, he was actually half Mede.

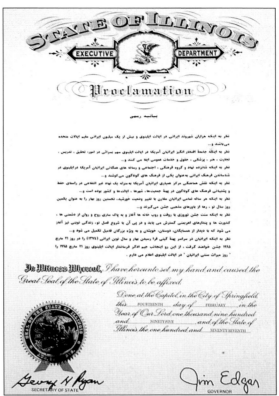

While many played a part in the genesis of the Illinois Iranian Heritage Day Proclamation, Iranian community activist Amir Noormandi endeavored tirelessly, along with the Iranian American Cooperation Center, to make the day of celebration a reality. The main text of the Proclamation (1995) reads as follows:

Whereas, there are thousands of Iranian Americans who reside in Illinois and more than one million throughout the United States; and

Whereas, the proud Iranian American community of Illinois has made tremendous contributions in research, teaching, medicine, law, business, arts, and public service; and

Whereas, there are 16 community groups, media, and cultural entities of Iranian American organizations in Illinois who are active in promotion of multiculturalism; and

Whereas, the Iranian American Cooperation Center, a not-for-profit organization, serves as the coordinating body striving to unite our communities, cities, states, and the nation through cultural awareness and education for the preservation of our diverse spectrum of cultures; and

Whereas, the first day of Spring is celebrated as New Year's Day among all Iranians, regardless of their religious beliefs. "Now Rouz" (the new day) is celebrated on March 21st of each year at the time of the vernal equinox; and

Whereas, the traditional "Now Rouz" celebration begins with spring cleaning. This tradition of spring cleaning is extended to the cleansing of the body and soul from animosity, grievances, and evil thoughts. A fresh start with a fresh season is to follow the visiting and greeting one's neighbors, friends, relatives, and especially the elders in the family; and

Whereas, Iranians throughout the world will celebrate the arrival of Spring, the Iranian New Year 1374, on March 21, 1995;

Therefore, I, Jim Edgar, Governor of the State of Illinois, proclaim March 21, 1995, as Iranian Heritage Day in Illinois.

(Image by Amir Noormandi. Courtesy of d'Last Studios.)

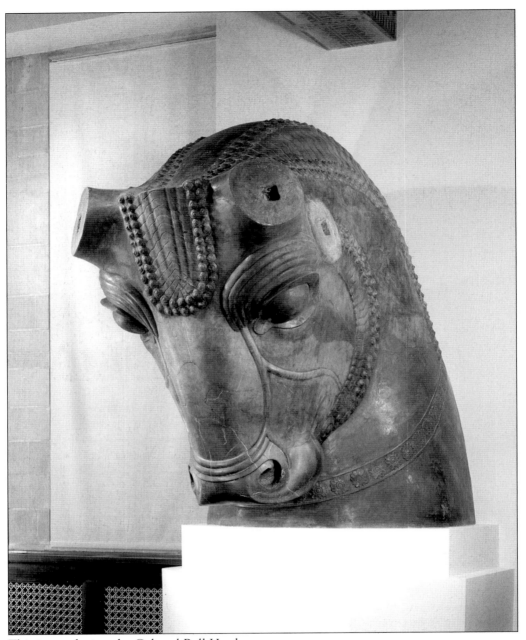

This image depicts the Colossal Bull Head:

 Perspepolis, Achaemenid Period, c. 486–425 B.C. Carved in the court style typical of the two guardian bulls flanking the portico of the hundred-columned Throne Hall at Persepolis. The heads of the bulls projected in the round and the bodies were carved in relief on the sidewalls of the porch; the ears and horns had been added separately. The use of pairs of guardian figures such as these to protect important buildings was a common architectural feature in the ancient Near East.

(Image and caption courtesy of the Oriental Institute of the University of Chicago.)

Shown here is the Foundation Slab of Xerxes:

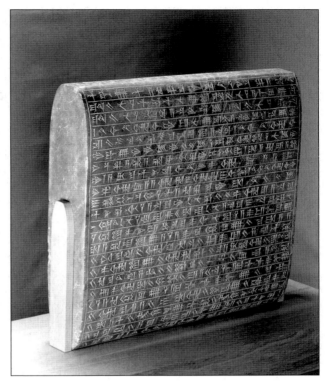

Persepolis, Achaemenid Period, c. 485–465 B.C. This stone tablet inscribed with Babylonian cuneiform characters lists the nations under Persian rule shortly after the uprisings that occurred when Xerxes came to the throne. Although the tablet was intended as a foundation deposit to be placed beneath a corner of one of Xerxes' buildings, it apparently was never used. It was found along with other tablets bearing the same text in Old Persian and Elamite employed as a facing of a mud brick bench in the garrison quarters at Persepolis.

(Image and caption courtesy of the Oriental Institute of the University of Chicago.)

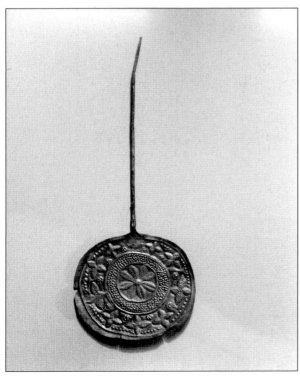

At left is a Disc-Headed Pin,:

Surkh Dum-i-Luri, Early Iron Age III, c. 750–700 B.C. Large numbers of decorated disc-headed pins were found in the sanctuary at Surkh Dum-i-Luir. They may have been votive offerings to a goddess or deposits verifying contracts among nomadic peoples moving through the area. The decoration of this example, with an eight-petaled central rosette and surrounding borders of smaller rosettes and punctate patterns, is typical. The tiny incised lion's (?) head faces away from the shaft because the pins were worn with the head hanging down and the shaft pointing up.

(Image and caption courtesy of the Oriental Institute of the University of Chicago.)

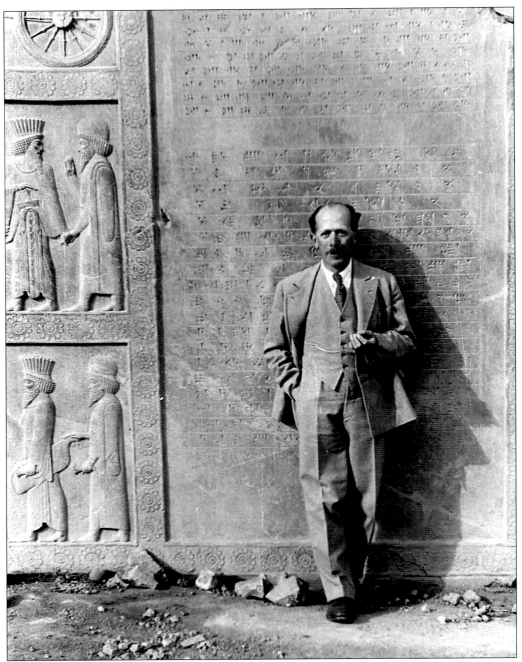

This portrait shows Dr. Ernst Herzfeld, field director of the Persepolis Expedition of the Oriental Institute of the University of Chicago, photographed in front of Perspolis reliefs by James Henry Breasted, Jr., February 23, 1933. Dr. Herzfeld was the first archeologist who directed archeological diggings in Perspolis. (Image and caption courtesy of the Oriental Institute of the University of Chicago.)

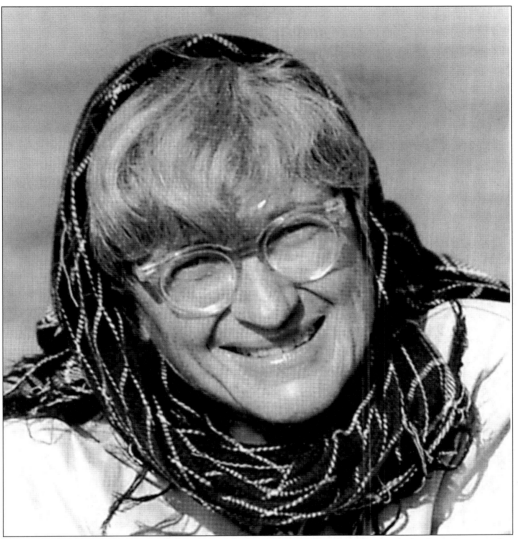

Dr. Helene Kantor (1919–1993) was Professor of Near Eastern Art and Archaeology at the University of Chicago and a pre-eminent Iran archaeologist. Dr. Abbas Alizadeh, an Iran archaeologist at the University of Chicago wrote the following in Professor Kantor's obituary for the Oriental Institute:

> Helene Kantor conducted field work at . . . Chogha Mish, Chogha Banut, and Boneh Fazili in Iran. Iran held special fascination for her and played a significant part in her archaeological career. Her investigations at Chogha Mish started in 1961 and ended in 1978. She contributed greatly to the understanding of the pre-historic and proto-historic life in southwestern Iran by publishing a number of important articles. . . . Her love for Iran and the bond of friendship she had developed with the villagers in the vicinity of Chogha Mish had become so strong that she had planned to live in the village of Doulati, Khuzestan, after she retired. Unfortunately, the political upheavals in Iran deprived her from reuniting with, as she put it, her people, calamity from which she never recovered.

(Image and quote courtesy of the Oriental Institute of the University of Chicago.)

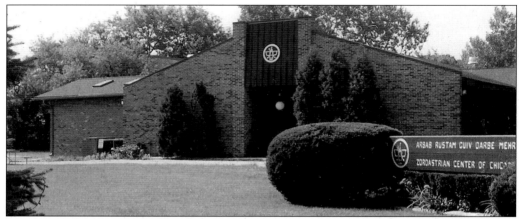

Above: Arbab Rustam Guiv Darb Mehr, the Zoroastrian Center of Chicago, was built in 1983. Iranians, though most of them were converted to Islam, still cherish their Zoroastrian heritage. "Good Thoughts, Good Deeds, and Good Words" are the three golden rules of Zoroastrianism that every Iranian child and adult knows, repeats, and respects. (Courtesy of Keikhosrow Mobed.)

Left: March 26, 1994 marked the first time Nowrouz was celebrated as the "Festival of Life" in the State building in downtown Chicago. (Image by Amir Noormandi. Courtesy of d'Last Studios.)

Right: A Haft-Seen (the symbolic spread of Nowrouz) was displayed in the State Building for the first time ever on March 21, 1995. (Image by Amir Noormandi. Courtesy of d'Last Studios.)

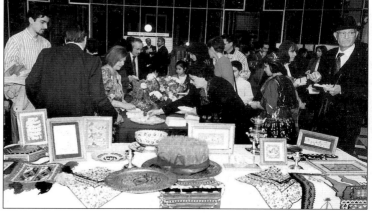

Right: The third celebration of Nowrouz, the "Festival of Life," was held in the state building on March 31, 1996. (Image by Amir Noormandi. Courtesy of d'Last Studios.)

Below: An original proclamation of March 21, 1995 as Iranian Heritage Day in Illinois is presented to Mr. Reza Toulabi, owner of Reza's Restaurant (March 31, 1996). At left below is Mr. Amir Noormandi, who gave of his time and energy to make this proclamation a reality. At right is the governor's Special Assistant on Ethnic Affairs Ms. Pat Michalski. (Courtesy of d'Last Studios.)

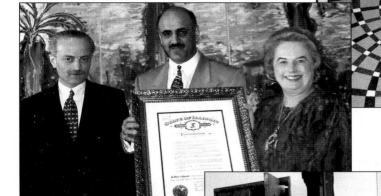

Right: Iranian Cultural Society members Mrs. Minoo Sohaey and Mrs. Mahin Pirnazar show their joy and pride for Nowruoz in front of Haft-Seen, *c*. 1998. (Courtesy of The Iranian Cultural Society.)

Left: Sabzeh, a green plant, is a traditional symbol of the arrival of triumphant spring and the renewal of life. This picture shows the Iranian Cultural Society's Haft-Seen in March, 1986. (Courtesy of The Iranian Cultural Society.)

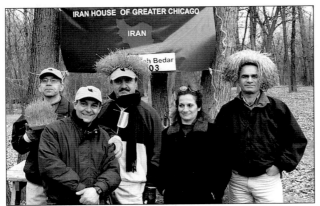

Iranians celebrate the end of Nowrouz on the thirteenth day of the new year, Sizdeh Bedar Day! They go out of town or to parks to picnic, taking their homemade green plants to leave on a river, stream, or pond. Nowadays, Sizdeh Bedar ceremonies are partially performed to get rid of bad luck and omens for the year. In recent years, members of Iran House of Greater Chicago have regularly held the Sizdeh Bedar on the first Sunday of April. In earlier years, Sizdeh Bedar was held by the Iranian American Society. Shown here are, from left to right, Mr. Hassan Rashedi, Mr. Tony Roshangar, Mr. Bahidad Javid, an associate, and Mr. Yadi Babapour (April 2003). (Courtesy of Iran House of Greater Chicago.)

Pictured above are more Sizdeh Bedar celebrants. (Courtesy of Iran House of Greater Chicago.)

Iran House executive members are at work, right, serving food at Sizdeh Bedar. On the right is Ms. Simin Hemmati Rasmeussen, one of the active members of the Iranian community. (Courtesy of Iran House of Greater Chicago.)

32

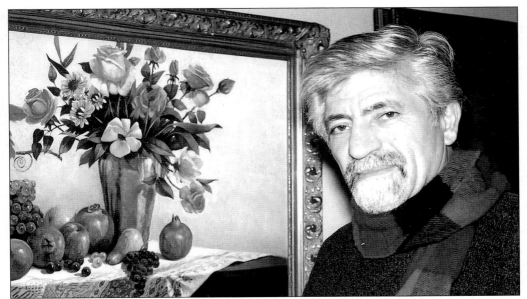

Minas Gharibian is an Iranian Armenian painter. His Gallery is on Peterson Avenue in Chicago. Gharibian's biography states:

> [He] was born in 1947 in the Armenian village of Gharghoon [Iran]. As a young boy, he was seldom interested in his studies, nor anxious to achieve high scores. . . . He had all the prerequisites of being a free spirit at an early age. During his high school years, his talent for drawing pictures and painting various subjects was discovered. . . . In 1970, he began to establish himself in his chosen field. . . . He arrived in the United States in 1979. He quickly adjusted to his new home in Chicago and began pursuing his artistic goals immediately. He began his association with Merrill Chase Galleries. . . . He opened his own Sevan Gallery in June 1980.

(Courtesty of Ario.)

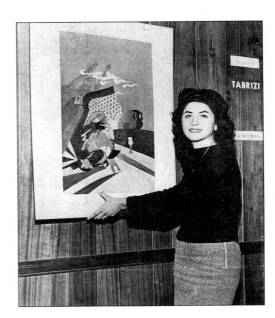

Ms. Manijeh Tabrizi, one of the first Iranian artists in Chicago, came to the city in the early 1960s. (Courtesy of Manijeh Tabrizi.)

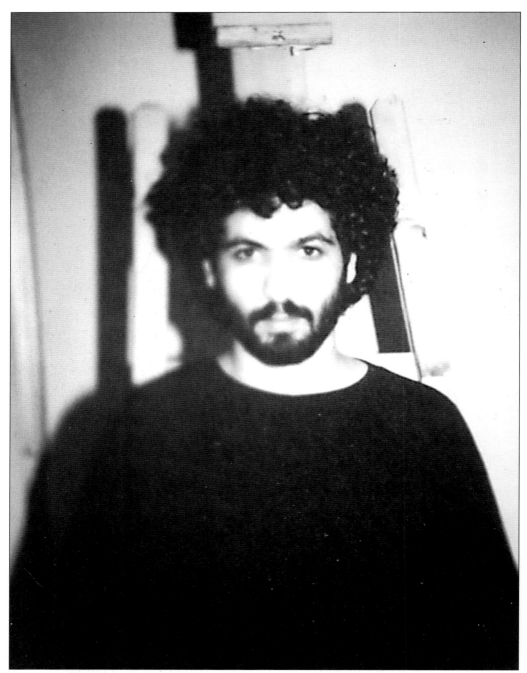

Ario Mashayekhi is one the most prolific Iranian painters living in Chicago. Ario came to Chicago in December 1978 and studied fine arts at the University of Illinois in Chicago. While he is primarily a painter, he is also engaged in various other artistic endeavors, such as film and theatre acting. Ario is among the most prominent human rights artists in the Iranian community living abroad. He is the only person from the Iranian community mentioned in Encyclopedia Chicago. Ario works in his studio in Chicago. (Courtesy of Dimitra Zirou.)

This drawing is by Ario Mashayekhi. (Courtesy of the Chicago Reader © 1992, Chicago Reader, Inc.)

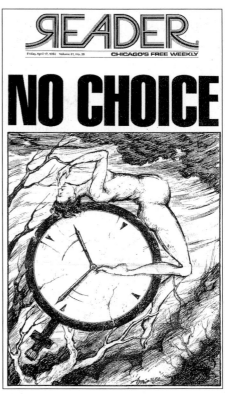

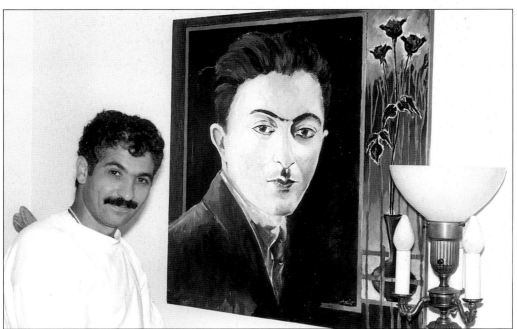

Ario stands next to his painting of Sadegh Hedayat, the most important and widely read novelist of twentieth century Iran. (Courtesy of Ario.)

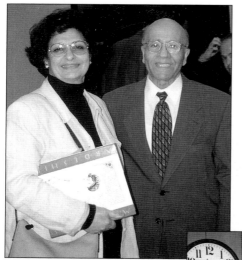

Left: Mahin Ghanbari, M.F.A., and Dr. Rahmat Pirnazar, M.D., pose together in 2001. Mahin Ghanbari was an Iranian artist living in Chicago until 1995. A well-known ceramics artist, she was the owner of Mahin Gallery in Winnteka, Illinois, before she left the Chicago area. She and her husband, Dr. Hossein Ghanbari, came to Chicago in 1982, and from the beginning, they were involved in numerous artistic, cultural, and community organizations and activities. Mahin Ghanbari was president of the Iranian Cultural Society in 1994. She now lives in Washington D.C. and continues to keep her ties with her "beloved" Chicago and her friends here. (Courtesy of Ario.)

Right: The late Abbas Radjaei (1993), born in Shiraz, Iran, was an award-winning painter and a longtime resident of Chicago. He lived in Chicago after 1966. He told a student newspaper (the Lincoln Clarion) that "my home city of Shiraz had a great effect on my painting." He was a generous artist who would give of his art as a contribution to many social and cultural causes. Throughout his life in Chicago, he kept abreast of developments in his beloved homeland, Iran, as he was often seen in Persian stores on Clark Street Friday afternoons, picking up the latest of Persian weeklies. He died in 2003. (Courtesy of Ali Babazadeh.)

Right: Hannibal Alkhas is a well-known, Chicago-educated Iranian painter who lives in Iran. He achieved his education in Arts from Loyola University, the University of Chicago, and the School of Art Institute of Chicago in the 1950s. "Alkhas draws heavily from ancient Assyrian relief sculpture and religious art to express the major theme of his work: man in search of beauty." Alkhas has been a frequent guest of Iranians and Assyrians in Chicago. (Quote courtesy of the Iranian Artists Exhibition brochure. Image courtesy of Ario.)

The Foundation for Promoting Iranian Arts, founded and managed by Sohrab and Farzad Abtahi, held an unprecedented and large-scale Iranian Artists Exhibition in Chicago in July 1989. Artists came from all over the world. (Courtesy of Sohrab Abtahi.)

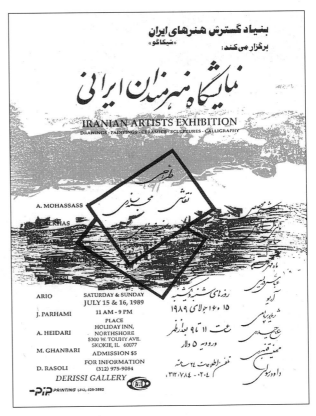

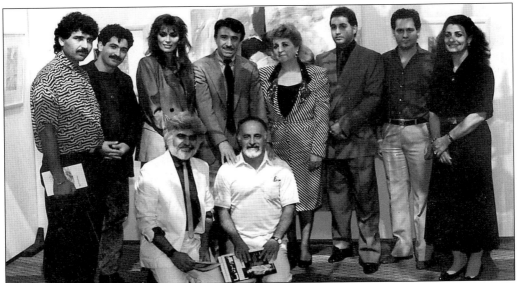

This picture includes most of the participants in the Iranian Artists Exhibition (July 1989). Shown standing, from left, are: Hesam Abrishami, Ario Mashayekhi, Jila Parhami, Ali Haidari, Mahmehr Golestaneh, Farzad Abtahi (organizer), Sohrab Abtahi (organizer), and Mahin Ghanbari. Seated, from the left, are: Abbas Derissi and Hanniball Alkhas. (Courtesy of Ario.)

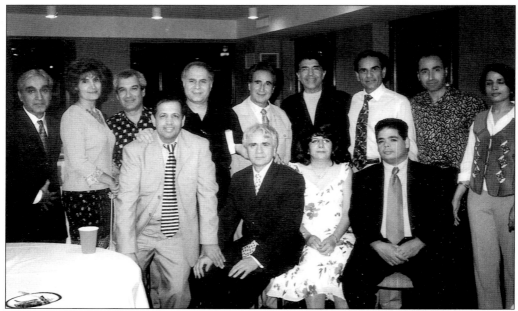

Poetry and appreciation for it are an inseparable part of Iranian culture and identity. Iranians everywhere, including in the United States and Chicago, have always and regularly held poetry events. In Chicago, there has been a monthly poetry night since the 1980s. This picture shows a number of founders and regular participants in the poetry night, including Mr. Ali Babazadeh (far left), Dr. Kamal Modir (fifth from left), and Ms. Ghodsi Sharifi (seated second from right). (Courtesy of Ali Babazadeh.)

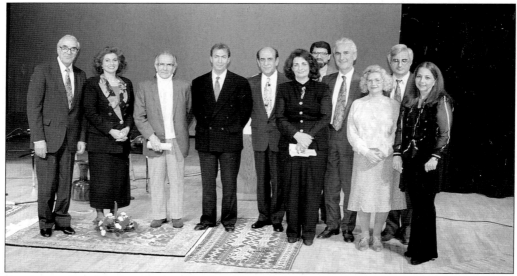

Participants in the annual poetry night (December 19, 1993) pose for a collective picture. Iranians in Chicago always enjoy the Iranian Cultural Society's poetry night at Northeastern Illinois University, which was first held in 1992. Mrs. Mahin Ghanbari (standing sixth from right), then the vice president of the Iranian Cultural Society, was the principal founder. (Courtesy of the Eghbali family.)

Right: Mrs. Ghodsi Eghbali (2003), an artist by education, in association with her husband, Dr. Hassan Eghbali, and Dr. Rahmat Pirnazar, has been ably and successfully organizing and hosting the Iranian Cultural Society's annual Persian Poetry and Music program since 1995. A packed audience at Northeastern Illinois University's recital hall enjoys this program every year. The annual program has grown into a celebration of Mehergan, the ancient Iranian celebration of fall. (Courtesy of The Iranian Cultural Society.)

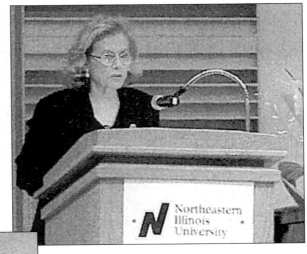

Left: Mehdi Nafici, president of the Iranian Cultural Society, welcomes the audience to the annual poetry night in October 2003. (Courtesy of The Iranian Cultural Society.)

Right: Mr. Ali Babazadeh (1992), a Chicago-based poet, recites one of his poems at the first annual Iranian Cultural Society's Persian poetry and music night at Northeastern Illinois University's Unicorn Hall. (Courtesy of Ali Babazadeh.)

Ms. Atissa Azar, a dance artist, performs a Persian dance at the poetry night in 2003. (Courtesy of The Iranian Cultural Society.)

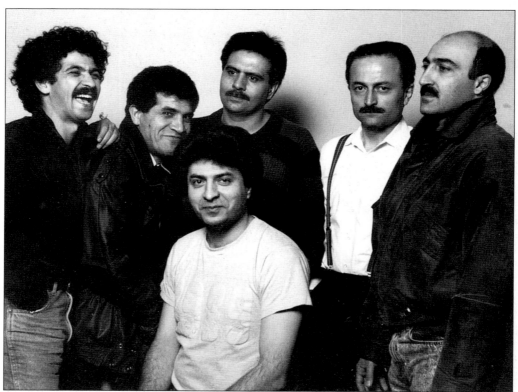

Group 4+1 and members of the Iranian Theatre Group are part of the team who brought *Successor*, a play by Gholam-hossein Saedi, to stage in 1992. Shown standing, from the left, are: Ario, Heshmat Shekaloo, Abolfazl Shansi, Amir Noormandi (producer), Cyrus (associate), and Saeid Lahouti (seated, director and actor). This Persian play, for the first time in Chicago, was simultaneously translated in English via headphones. (Courtesy of d'Last Studios.)

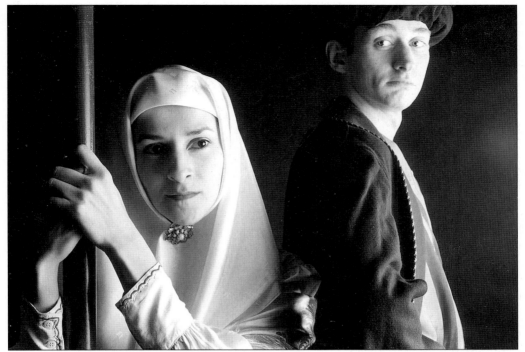

This is a scene from the play *Behind the Curtains, the story of Tahereh (Qurrat ul Ayn)* by Ezzat Goushegir. This play was produced by Amir Noormandi in April 1995. (Image by Amir Noormandi. Courtesy of d'Last Studios.)

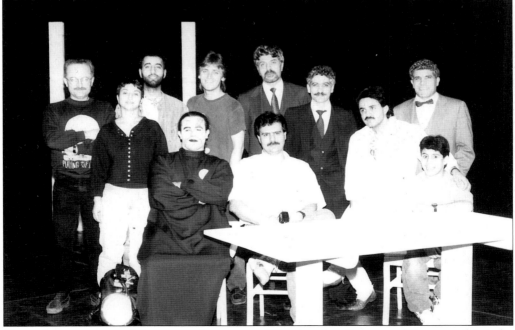

Shown here are more of the cast and support staff for the play, *Successor*. (Courtesy of Ario.)

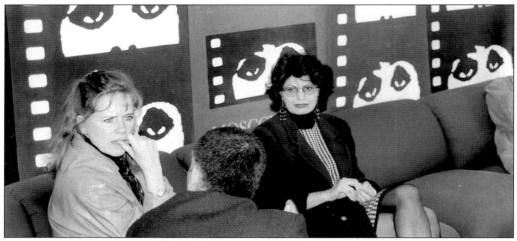

Ezzat Goushegir (right), a graduate from the University of Iowa, is a playwright and short story writer. She also teaches at De Paul University in Chicago. She has authored several books of short stories in Persian. Many of her works have been staged, including *Behind the Curtains*, produced by d'Last Studios. In the picture, Goushegir is sitting with Liv Ulman, the film director and actress. (Courtesy of Ezzat Goushegir)

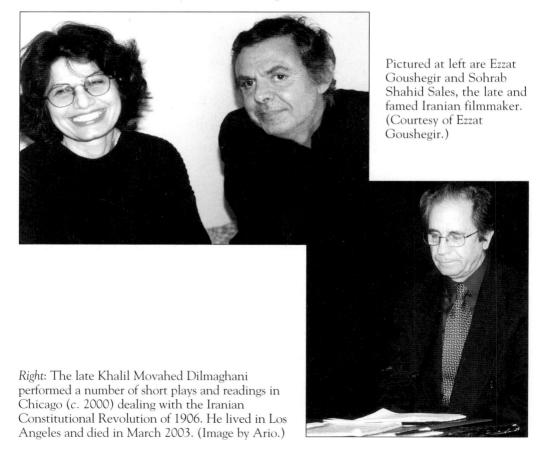

Pictured at left are Ezzat Goushegir and Sohrab Shahid Sales, the late and famed Iranian filmmaker. (Courtesy of Ezzat Goushegir.)

Right: The late Khalil Movahed Dilmaghani performed a number of short plays and readings in Chicago (*c.* 2000) dealing with the Iranian Constitutional Revolution of 1906. He lived in Los Angeles and died in March 2003. (Image by Ario.)

Three

IMMIGRANT PROFILES AND CONTRIBUTIONS

There are two distinct and major patterns of Iranian immigration to Chicago. The first is that of medical and other students who began arriving in Chicago in the late 1950s and throughout the 1960s and 1970s. And the second is that of Iranians of various professional and social backgrounds who arrived here in the aftermath of the Iranian Revolution of 1979.

At the time of the Iranian Revolution of 1979, Iranian students studying abroad were estimated at 50,000. A large portion of these students studied in the United States and an estimated number of about 700 were in Chicago. Since the late 1950s and especially through the 1960s and 1970s, Chicago was a major city for Iranian students. Many of these students completed their studies and returned to Iran, while many others stayed here for life. For those who left for Iran, many returned in the aftermath of the Iranian Revolution.

Medical doctors are the first distinct group of Iranians who made Chicago their permanent place of life, beginning with their arrival in Chicago in the late 1950s and through the 1960s and 1970s. Most of the doctors came with the intention of completing their residency in the Chicago area. Among the first group was Dr. Javad Hekmat-Panah of the University of Chicago, an authority in neurology, who came to Chicago from Esfahan in the late 1950s. Included among other early medical doctors are Dr. Rahmat Prinazar, Dr. Hassan Najafi, Dr. Houshang Javid, Dr. Faramarz Salimi, Dr. Kamal Modir , Dr. Sharifi , Dr. Nejat, Dr. Ebroon, Dr. Amir Motarjemi, Dr. Badri, Dr. Ebrahim Fallah, Dr. Majid Vaseghi, and Dr. Cyrus Serry and his wife, Dr. Mahin Serry.

The late Dr. Mahmoud Hashemi, who over the years became a well-respected community leader, was one of these medical doctors who came to Chicago in 1958. Dr. Hashemi, equally well educated in Persian literature, began his medical career at Edgewater Hospital. For more than three decades, until his death in early 1992, Dr. Hashemi and his wife, Mrs. Monireh Hashemi—while fully embracing Chicago as their new home—would always display a pure love for Iran and Iranian culture and would make their home into a welcoming place for their friends and fellow Iranians. This was especially true during Nowrouz, when a lot of Iranians paid New Year's visits to their house and each, including the children, were most welcomed by the Hashemi family. During Nowrouz, no child left their house without Aidi, the new paper money that children receive from the elder as the Nowrouz gift.

In the second half of 1970s, an increasing number of non-M.D. and non-student middle class professional Iranians began to arrive in Chicago. This immigration began to experience a considerable rise right before, and especially in the aftermath of, the Iranian Revolution of 1979. The Iranian Revolution, an earth-shaking event in the history of the twentieth century, resulted in a massive exodus of educated, middle-class Iranians from Iran. A large number of these Iranians of various segments of Iranian society and different parts of Iran began to settle in Chicago, as then imagined, a temporary safe haven. The irony of the Iranian revolution was that for all its anti-Western, and especially anti-U.S. rhetoric, it caused a large immigration of Iranians—which still continues—to the West, especially to the United States.

For more than a decade, most of these Iranians thought of their life in the United States as temporary. They hoped for a better political climate in Iran so they could return. The popular

phrase among these Iranians was that "we live everyday with our suitcases in hand." As the hopes for an ideal political change in Iran faded, the reality of raising children in a new land and the economic demands associated with it became more pressing, and the nascent Iranian community in Chicago and elsewhere became more solidified, Iranians began to more fully settle in Chicago and the United States and accept it as their new home.

Many of these new immigrant families endured a hard life before they achieved relative prosperity. Many of these Iranians, with higher education degrees and formerly holding administrative, engineering, entrepreneurial, and academic types of jobs in Iran, had to work several jobs in order to maintain their living here and in some cases send money for their families in Iran. Today, Iranians living in Chicago are well educated, prosperous, and law abiding citizens of the United States. Most of the immigrants and their families now go and visit their beloved homeland on a regular basis. However, most of them have also realized and welcome the fact they already have another homeland in Chicago and the United States.

The upshot of the pre- and post-revolutionary Iranians settling in Chicago is the formation of a viable Iranian community in Chicago with their variety of contributions to Chicago and beyond. There is no hospital in the Chicago area that does not include prominent Iranian doctors. These doctors have been treating their patients in Chicago with care and a gentle touch of Persian kindness. Dr. Gholam Peyman, formerly of Chicago, is an authority in eye surgery. There are also a number of Iranian dentists serving thousands of patients in Chicagoland. Among them are Dr. Reza Mostofi, Dr. Azadeh Afzali-Mohammdi, Dr. Shafa Amir-Soltani, Dr. Nasrin Azim-Zadeh, and Dr. Mohammad Khoshnood.

Iranian professors have taught and many continue to teach at virtually all public and private universities and colleges in Illinois. At Northeastern Illinois University alone, there are six Iranian professors, including Dr. Saba Ayman Nolly, Chair of Department of Psychology. Professor Mehdi Harandi, the head of graduate studies in computer science at the University of Illinois, Urbana-Champaign is an authority in his field, but is also known for his Persian poetry. Professor Gholamali Mansouri has been teaching at the University of Illinois, Chicago since the 1970s. Other professors, such as Professors Manuchehr Azad (Harper College), and Vali Siadat (head of the math department at Daley College) make significant contributions to student lives at Chicago community colleges.

There are also various other types of Iranian professionals, including teachers, lawyers, accountants, financial analysts, architects, computer analysts, public relations specialists, real estate agents, and mortgage brokers. Mark Anvaripour is the first Iranian lawyer in Chicago. There are a number of Iranian owned daycares and schools in the Chicago area as well; Dr. Moloud Motlagh, is the founder of a well-regarded Montessori school. Chicago also includes a number of Iranian business owners and entrepreneurs. Most prominent among them are Mr. Reza Toulabi and his brother Gholam Toulabi, owners of the Reza restaurants, and Mr. Cyrus Sadeghi, owner of the Cy's Seafood restaurants.

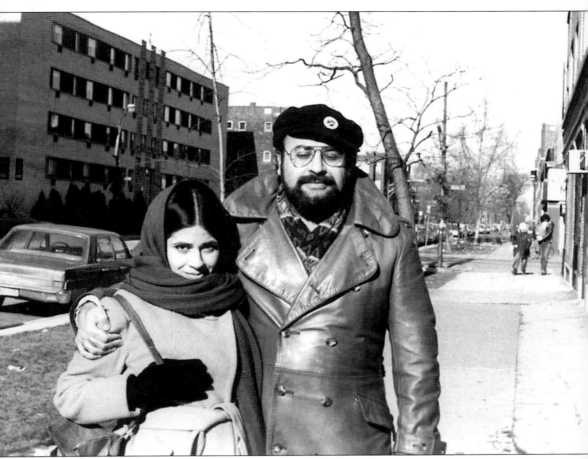

Pictured here are Laura and Frank Paz (sister and brother) in 1974. Laura, an Iranian Assyrian who was married to the late Farhad Dehghan, is an exemplary Iranian Assyrian American who cherishes and displays the best of her diverse cultural and national identities. (Courtesy of Laura Paz.)

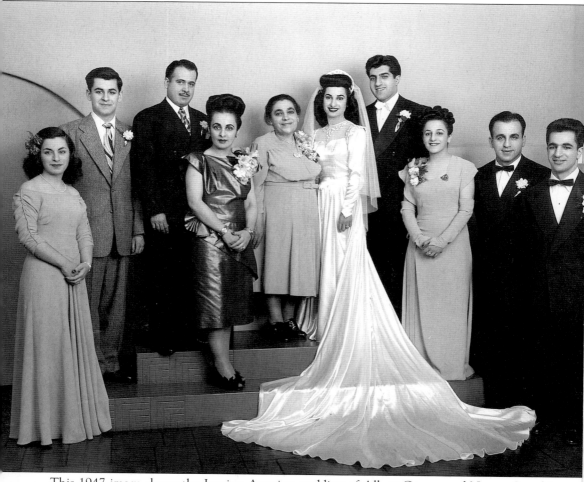

This 1947 image shows the Iranian-Assyrian wedding of Albert George and Norma Sayad in Chicago. Pictured here, from left to right, are: Florence Sayad (Yacuub), Frank X. Paz Jr., Frank X. Paz Sr., Sara Sayad Paz, Suria Sayad, Norma (bride), Albert (groom), Blanche Sayad, Samuel Sayad, and Daniel Sayad. (Courtesy of Laura Paz.)

Mr. Keikhosrow Mobed (right) came to Chicago from Germany in 1970 and joined his brother, Jahangir, in his Persian carpet business. Mr. Mobed is a well-respected member of the Iranian community in the Chicago area. This picture shows him with Mr. Rohinten Rivetna, the first president of the Federation of North American Zoroastrians, and Mr. Rivetna's daughter, Zenobia, in front of the Arbab Rustam Darb Mehr (Zoroastrian temple) in Lisle in 1983. (Courtesy of Keikhosrow Mobed.)

Shown here are a group of college instructors at the YMCA at Wabash Avenue and Wacker Drive (c. 1975). In the middle is Mr. Ahmad Neystani, a math instructor, who came to Chicago in the 1960s. On the right is Dr. Hossein Birjandi, who first came to Chicago in the 1970s as a student and later became an instructor at the YMCA. For Iranian students, the YMCA was a major center for education and their social and political activities prior to the revolution. (Courtesy of the Birjandi Family.)

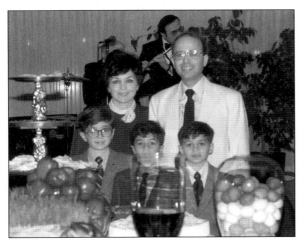

Dr. Bahram (Barry) Sadegi, M.D. and his wife, Gerri, with their three children celebrate Nowrouz in March 1985. Dr. Sadegi came to Chicago in the 1960s and has always been involved in various cultural works in the Iranian community. (Courtesy of The Iranian Cultural Society.)

47

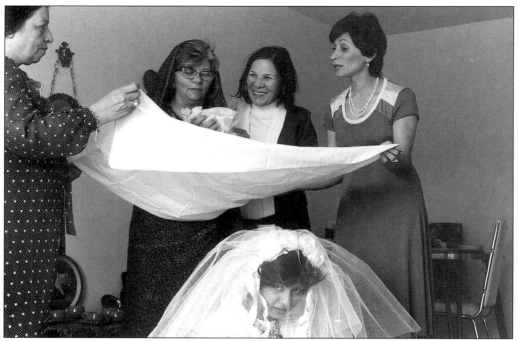

Pictured here is a student wedding in Chicago, July 9, 1976. Many Iranian students were married in Chicago, including Nahid Zahedi (the bride), who goes through the Persian marriage ceremony with her mother, sister, and other relatives. (Courtesy of the Birjandi Family.)

Dr. Hassan Eghbali, M.D., and his wife, Mrs. Ghodsi Eghbali, shown in November 1968, are both active members of the community, and are among the first medical doctor-families who came to Chicago. (Courtesy of the Eghbali Family.)

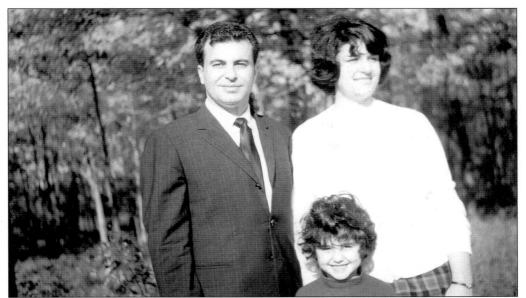

This 1966 picture shows Dr. Manouchehr Sohaey, a plastic surgeon, his wife, Mrs. Minoo Sohaey, and their Iranian-born daughter Roya in Atlantic City as they first entered the United States. Soon after, they moved to Chicago. (Courtesy of the Sohaey Family.)

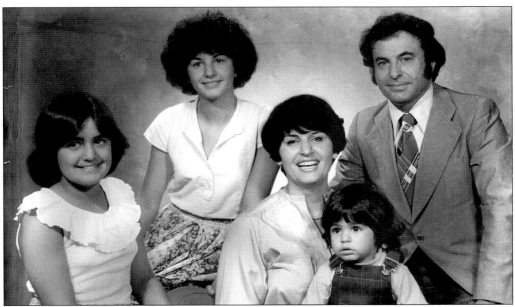

By 1978, the Sohaey family included Jasmine (left) and Christopher Kaveh (front, right), who were born in Chicago. Today, Roya is a medical doctor and a professor of medicine at Oregon Health and Science University. She has authored several books in her area of expertise. Jasmine is a marketing graduate from Northwestern University and lives in Iowa with her husband and her three children. Christopher graduated from Dennison University in Ohio and is now an entrepreneur in San Diego, California. Dr. and Mrs. Sohaey continue to live in the Chicago area and remain very active in the community. (Courtesy of the Sohaey Family.)

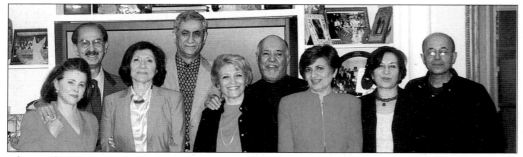

Above: The University of Tehran 1964 graduating class of medical doctors is photographed at the 2002 meeting of the Iranian American Medical Association (IAMA) in Chicago. All live in Chicago, except Dr. Amir Ghandchi and Dr. Vida Tavafoghi-Ghandchi, standing far left. Pictured next, from left to right, are: Dr. Mandan Farahati (obstetrician/gynecologist), Dr. Parto Rezai (obstetrician/gynecologist), Dr. Pouran Imani (psychiatrist/anesthesiologist), Dr. Manuchehr Imani (pediatrician), Dr. Mary Roushan (pathologist), Dr. Taraneh Firuzi (dermatologist), and Dr. Bahram "Barry" Sadegi (obstetrician/gynecologist). (Courtesy of Dr. Sadegi.)

Right: Dr. Mahmoud Hashemi, M.D., is giving a speech to a social gathering of Iranians, *c.* 1990. A popular community leader, Dr. Hashemi founded the Pars Educational and Cultural Society, and was known for his literary knowledge and wit. (Courtesy of the Akbari Family.)

Above: Celebrating the Persian New Year in 1985 are, from left: unidentified, the late Dr. Abbas Poorsattar, Dr. Kamal Modir, and Kiumars Haghighi. Dr. Kamal Modir, a psychiatrist practicing in Rockford, came to Chicago in the 1960s. (Courtesy of The Iranian Cultural Society.)

Right: Master santour player Kiumars Haghighi began his study of the instrument at age ten. As a teen, he performed on the radio station of Mashad, Iran, and the National Iranian Radio in Tehran. At 19, he was invited to join the Iranain Ministry of Education and Art. He performed as featured soloist in the academy orchestra and appeared regularly on National Iranian Television. Kiu was an instructor at the Ministry until 1965 when he left to study in the United States. Kiu Haghighi's musical career has included performances around the world. (Courtesy of Mr. Haghighi's website.)

Right: Dr. Hassan Moghadam, M.D., specialist in neurology at Edward Hospital in Naperville, is among the Iranian physicians who came to the U.S. in the mid-1980s, after the revolution. Dr. Moghadam is seated first from the right with his colleagues at Sina Hospital in Tehran, *c.* 1964. (Courtesy of Dr. Hassan Moghadam.)

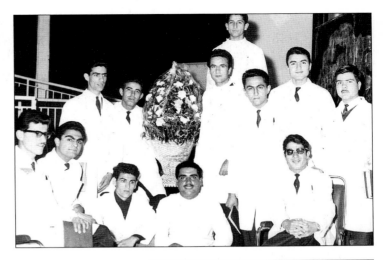

Right: Dr. Fatima Fereshteh Moghadam (second from right), wife of Dr. Hassan Moghadam, is a pediatrician at Edward Hospital in Naperville. (Courtesy of Dr. Hassan Moghadam.)

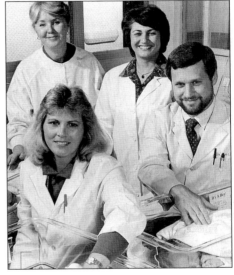

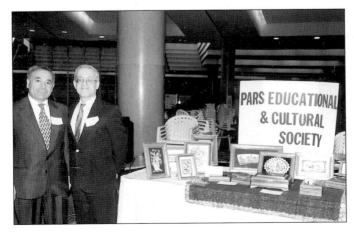

Left: Dr. Ali Darki (at right), M.D., and Dr. Rahim Behina, M.D., are shown next to the Pars Educational and Cultural Society table at the 1995 Persian New Year celebrations at the State Building. Drs. Darki and Behnia both have served the Iranian community of Chicago and are past presidents of their Society. (Image by Amir Noormandi. Courtesy of d'Last Studios.)

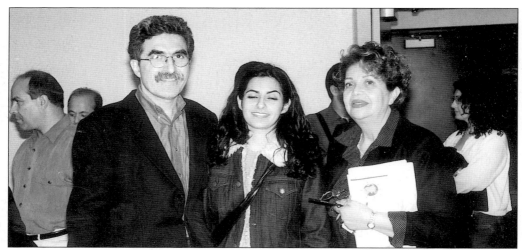

Dr. Ali Keshavarzian (left), former director of Loyola University's gastroenterology division, is head of gastroenterology at Rush University Medical Center. Shown here in 2001 with his daughter, Ghazal, and Ms. Manijeh Marashi, Dr. Keshavarzian moved from London to Chicago in the mid-1980s with his wife, and two children. A prominent researcher, professor, and practitioner, Dr. Keshavarzian was interviewed for a story on WGN9-TV on January 4, 2004, about his research on the harmful effects of alcohol. The story included the following:

> That's his [Alex, the patient's] goal for joining a Rush Presbyterian St. Luke Medical Center study on alcoholic liver disease. Alex wants to prevent others from feeling his pain. And Dr. Keshavarzian wants to prevent anyone from being susceptible to liver damage. . . . 'The aim of the study is to be able to identify patients at risk and the level of risk. Those that have compromised barriers, either on its own or after induced stress from arthritis medication, they can't drink even moderate amounts,' Dr. Keshavarzian says.

(Courtesy of Ario.)

Mr. Javad Jafari and his wife, Mrs. Ashraf Jafari, came to Chicago after the revolution of 1979. Both are prominent members of Persian language, poetry, and literature gatherings in Chicago. Mr. Jafari, a poet and writer, has authored many books. He and his family are always involved in cultural affairs within the Iranian community in Chicago. (Courtesy of Ali Babazadeh.)

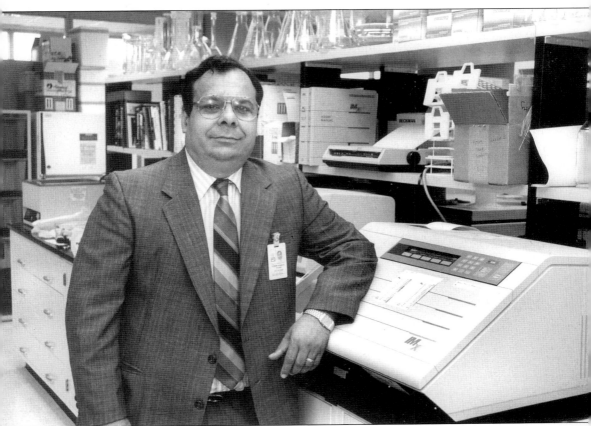

This 1994 image shows Dr. Hossein Ghanbari at the world headquarters of Abbott Laboratories in Chicago where he worked for ten years, developing several pharmaceutical and diagnostic products. One of his notable accomplishments was the development of "ALZ-ELA brain assay," which measures Alzheimer's disease-associated protein in brain tissues—the first Alzheimer's test marketed in the world. In 1990, his publication in JAMA (Journal of the American Medical Association) received extensive popular press coverage worldwide, including the New York Times, the Washington Post, and the Chicago Tribune. At Abbott, he was a member of the NDA Team for Leuporn, a very successful drug, and directed the Analytical Sections of an IND application for an antibody-based viral drug. He served on Abbott's Technical Board and was inducted into its Volwiler Society, a prestigious honorary organization that serves Abbott's recognition of the highest standards of scientific accomplishment. Dr. Ghanbari is presently the chairman, CEO, CSO and co-founder of Panacea Pharmaceuticals, Inc., located in Gaithersburg, Maryland. He is also the chairman of the board of the Alzheimer's Corporation based in Albuquerque, New Mexico. Besides their extensive professional accomplishments, Dr. Ghanbari and his wife, Mrs. Mahin Ghanbari (please see chapter two), were among the most active and helpful members of Iranian cultural and social affairs in Chicago. (Courtesy of Dr. Ghanbari.)

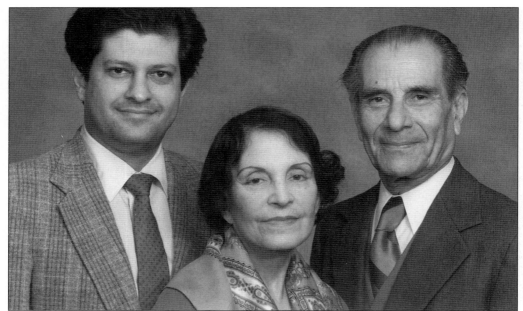

The Forough Family, c. 1979, includes, from left: Professor Cyrus Forough, Mrs. Fakhr-Zaman Forough, and Dr. Mehdi Forough. Dr. and Mrs. Forough came to the United States in 1978 to join their son in Bloomington, Indiana. They moved to Chicago in mid-1980s. All who know Dr. Forough are impressed by his vast, unmatched knowledge of Persian and international art, music, literature, and philosophy. Dr. Forough graduated with highest honors from Daneshsarray-Alli (Ecole Normal Superior) of Tehran. In 1938, he went to England and began seven years of study at the prestigious Royal Academy of Dramatic Arts in London. He later studied arts and literature at Columbia University. Besides his highly regarded writings and publications, Forough was the founder and president of the College of Dramatic Arts in Iran and taught at Tehran University for many years. Many of his students still live and perform in Iran, Europe, and the United States. Dr. Forough is a gentle, kind person, whose home in Chicago has always been open to any who wish to meet with him, or to learn from his vast knowledge and erudition. (Courtesy of the Forough Family.)

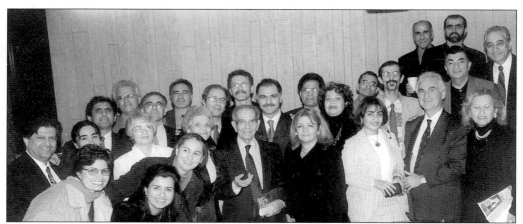

In this 2000 photograph, Dr. Forough's many friends and admirers surround him during an Iran House program in his honor (Courtesy of Iran House of Greater Chicago.)

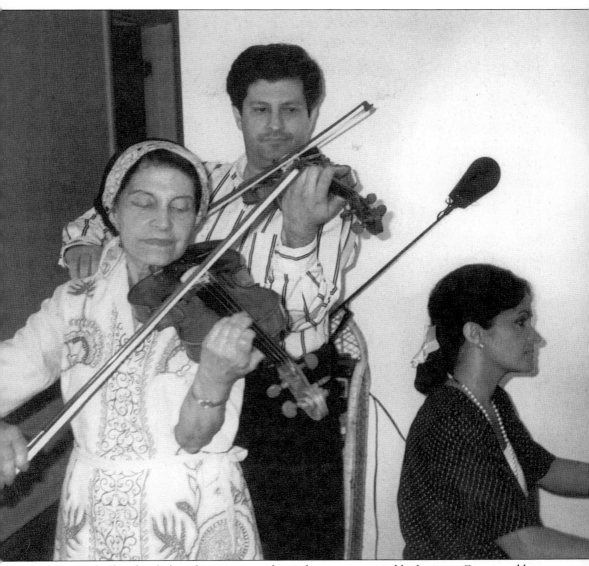

Mrs. Forough plays her beloved instrument, the violin, accompanied by her son, Cyrus, and her daughter, Leili. One can see the great influence of the musician mother on her children. Mrs. Forough was daughter of Haj Mirza Yahya Dowlatabadi, the famed Constitutional Revolutionary Era thinker and writer, member of the Parliament, and one of the prominent founders of modern schools in Iran. The first woman in Iran to study and play classical violin, Mrs. Forough showed keen and steadfast interest from childhood in performing the violin. She overcame many social barriers in order to learn and play the instrument, studying at the Brussels Royal Conservatory and teaching at the Tehran Conservatory and the University of Tehran. She married Dr. Mehdi Forough in 1949. Mrs. Forough died in 1991 in Chicago. (Courtesy of the Forough Family.)

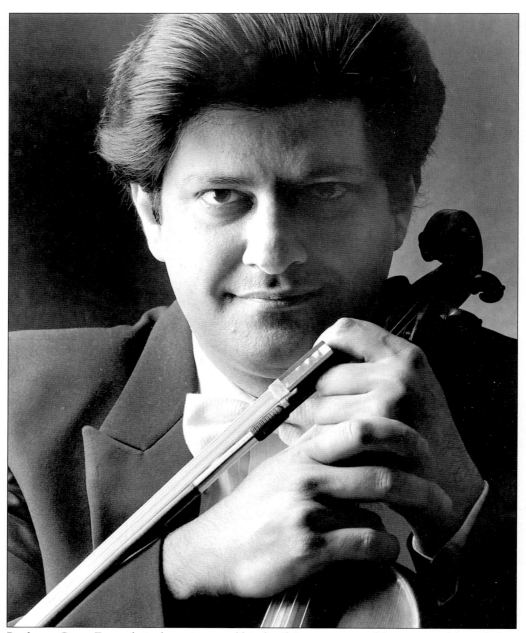

Professor Cyrus Forough is the epitome of his family's great musical heritage and knowledge. According to Ruggeiro Ricci, Forough is among "a handful of great violin teachers," and has performed as soloist in countless stages internationally. "At age nine he entered the Royal Conservatory of Music as a student of the renowned violinist Arthur Gruimaux. Further studies were with legendary violinist and pedagogues such as David Oistrakh at the Tchaikovsky Conservatory in Moscow, and with Josef Gingold at Indiana University. Professor Forough is a full-time faculty member at Carnegie Mellon University in Pittsburgh and is on the faculty at Roosevelt University College of Performing Arts in Chicago." (Text and image courtesy of the Forough Website.)

Professors Janet Afary and Valentine Moghadam are pictured at right, c. 2001. Professor Afary teaches history at Purdue University. She is also president of the International Society of Iranian Studies. She has lived in the Chicago area since the 1980s. Until 2003, Professor Moghaddam taught at Illinois State University in Normal, Illinois. They are both well-published in their academic communities. (Courtesy of Ario.)

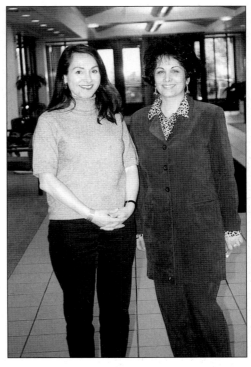

Dr. Ramin Ahamdi, M.D., c. 1988, is not officially a resident of Chicago, but used to visit the city frequently in the late 1980s as he studied for his medical degree in Wisconsin. He is currently an associate professor of medicine at the Yale School of Medicine and the founder of Griffin Center for Health and Human Rights. The center has conducted several Health and Human Rights projects in East Timor, Nicaragua, Uganda, and Guyana. Dr. Ahmadi also founded Women's Health Access Program, a center dedicated to addressing the health issues of uninsured women. The center was declared a National Center of Excellence by the Secretary of Health and Human Services. Dr. Ahamadi is a prolific author in both Persian and English. (Courtesy of Ario.)

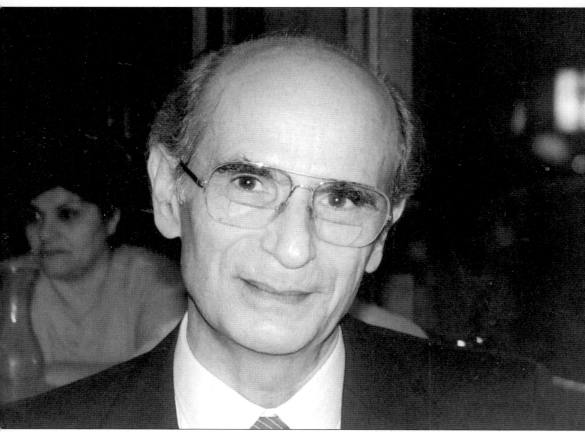

Dr. Heshmat Moayyad, shown here in 1988, has been professor of Persian language and literature at the University of Chicago since 1966, and is one of the most respected and prolific authorities on the subject in the world. With more than 200 scholarly publications, including dozens of books, he received his Ph.D. in Persian Literature, Islamic Studies, and German Language from the University of Frankfurt, Germany, in 1958. In addition to his career at the University of Chicago, Moayyad has taught at Instituto Universitario Orientale in Naples, Italy and at Harvard University. He and his wife, Ruth, who also speaks Persian fluently, were among the first Iranian families to make Chicago their permanent home. Dr. Moayyad is considered one the most prominent and well-respected members of the Iranian community in Chicago. (Courtesy of Dr. Moayyad.)

Right: Ms. Manijeh Marashi is a social worker at Apna Ghar, which provides shelter, counseling, and support for battered and abused women. This picture shows her with Cook County Treasurer Maria Pappas and the governor's Special Assistant for Ethnic Affairs Ms. Pat Michalski. (Courtesy of Manijeh Marashi.)

Left: Ms. Hamideh Nafici is a licensed social worker. She is affiliated with Hamdard Center, a primarily Muslim community social services organization in Chicago. (Courtesy of Hamideh Nafici.)

Left: Dr. Karim Pakravan is a vice president at JP Morgan Bank. With a Ph.D. in economics from the University of Chicago, he works as a global economist and FX strategist. Pakravan returned to Chicago after the revolution of 1979 with his wife and daughter. (Courtesy of Dr. Pakravan.)

Left: Shown here are Mr. Zia Majd, a former attorney-at-law in Iran, and the late Abbas Radjaei in 1993. Retired, Mr. Majd came to Chicago in the 1980s and stayed here through mid-1990s. He now lives in Seattle, Washington. (Courtesy of Ali Babazadeh.)

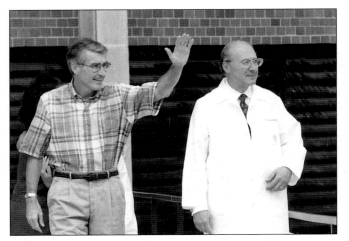

Governor Edgar waves to supporters following his successful heart surgery in 1998. He is accompanied by his cardiologist, the late Dr. Khosrow Amir Parviz, an Iranian American. Back in early 1960s, two other Iranian physicians, Dr. Houshang Javid and Dr. Hassan Najafi, performed a heart surgery on Richard J. Daley, mayor of the City of Chicago. (Image by Amir Noormandi. Courtesy of d'Last Studios.)

Governor Edgar and Mr. Noormandi shake hands, c.1997. Mr. Noormandi was the first Iranian appointed to a state board (appeals reimbursement) on September 1996. (Courtesy of the Illinois Ethnic Affairs Office.)

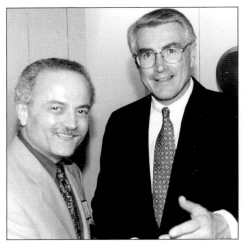

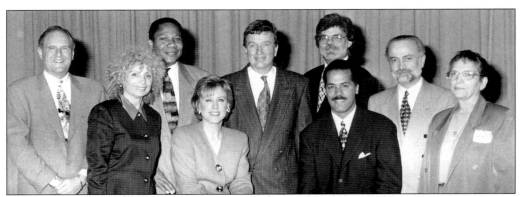

Mr. Noormandi represents Iranians in an Ethnic Town Hall Meeting sponsored by then Governor Jim Edgar's Office of Ethnic Affairs and WBBM-TV, Channel 2, on October 24, 1995. The Office of the Governor's newsletter stated that, "Over fifty ethnic leaders were asked to speak on behalf of their communities regarding Channel 2's coverage on issues pertaining to their communities. . . ." (Courtesy of d'Last Studios.)

For Iranians, hospitality is a cultural value. Being together at each other's houses is the favorite pastime of Iranians. These images shows the joy of togetherness for Iranian immigrants. (Courtesty of the Akbari Family.)

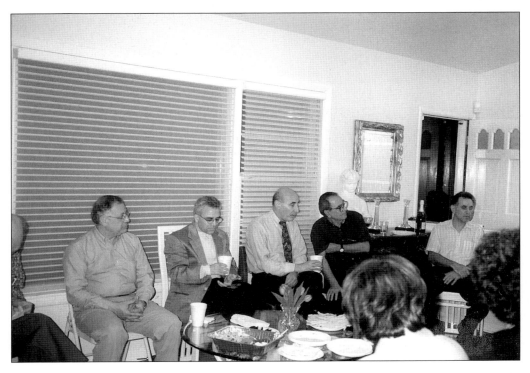

Right: A large number of Iranians have been to Dr. Reza Mostofi's dental office on Bryn Mawr Avenue at Kimball Avenue. Among Iranians, Dr. Mostofi is known as welcoming, caring, and generous. (Courtesy of Ario.)

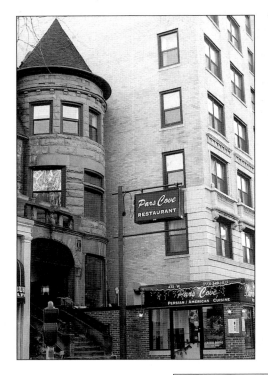

Left: Pars Cove at 435 Diversy Avenue is the oldest Persian restaurant in Chicago.

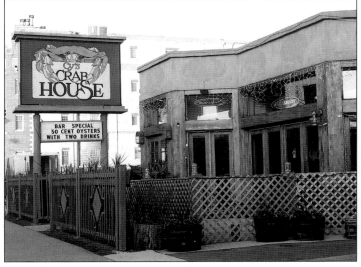

Right: Cy's Crab House on Ashland, founded by another successful Iranian entrepreneur, Mr. Cyrus Sadeghi, is one of the four Cy's restaurants in Chicagoland. (Courtesy of Ario.)

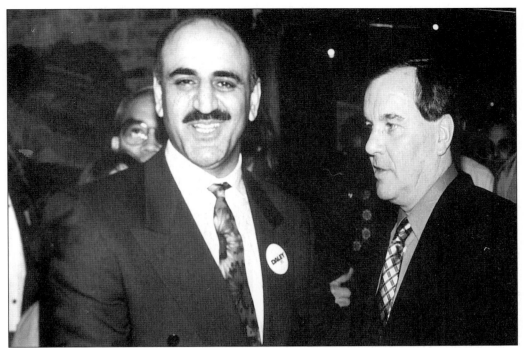

Mr. Reza Toulabi is pictured here with Mayor Richard Daley. Mr. Toulabi and his brother, Gholam, started the smaller original Reza Restaurant on Berwyn Avenue but were able to rapidly expand and modernize. Reza Restaurant in downtown is considered among the largest Persian restaurants in the world. (Courtesy of Mr. Reza Toulabi.)

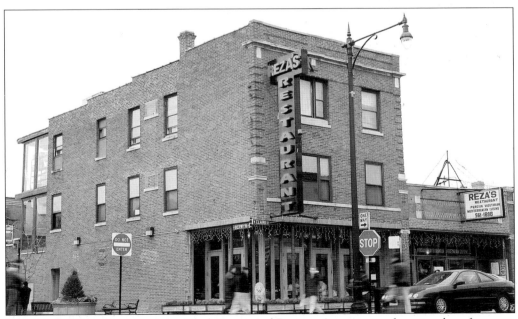

The original Reza Restaurant on Clark Street and Berwyn Avenue, is a favorite place for many Chicagoans, including Iranians. (Courtesy of Ario.)

Right; Noon-o-Kabab restaurant is located on Kedzie Avenue. The Naghavi family has created an atmosphere of Iranian hospitality in their restaurant. (Courtesy of Ario.)

Left: Souren Persian Restaurant on Sheridan Road in Rogers Park is the newest Persian restaurant in Chicago. (Courtesy of Ario.)

Right and below: Arya and Pars, both Persian grocery stores on Clark Street, may have been visited by every Iranian in Chicago—for the aura and aromas of the homeland, and for the range of favorite Persian items, be it a food item or the CD of a Persian singer from California. Mr. and Mrs. Babaian (Arya Store) and Mr. and Mrs. Haghighi (Pars Store) are always most welcoming to all of their customers. (Courtesy of Ario.)

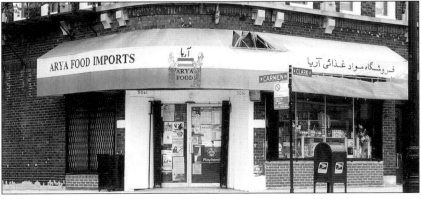

Behrouz Azarnoosh came to Chicago as a student in the 1960s. He has always been an active and helpful member of the Iranian community. He lives in Chicago with his wife, Zari, and his two daughters, Bita and Mina. (Courtesy of the Akbari Family.)

Fraydoun Dadras is another Iranian student immigrant and active member of the Iranian community in Chicago. (Courtesy of the Akbari Family.)

Hossein Bastanipour (at right), an accountant and businessman, was a longtime resident of Chicago who moved to California a few years ago. Eghbal Khodaveissi, a marketing expert, is another longtime resident of Chicago. In the 1990s, Mr. Khodaveissi published a periodic publication named Jarchi and printed several Iranian yellow pages. (Courtesy of Ali Babazadeh.)

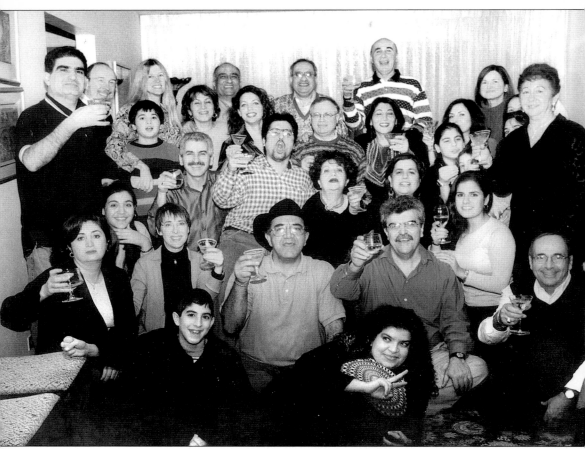

Beginning in 1977, and until Farhad's untimely death in 2003, Laura Paz and Farhad Dehghan held an annual New Year's party in their home. This picture was taken during a joyous moment on December 31, 2001. Shown, left to right, are: (front row) Babak, Aitak; (second row) Homa, Anya, Khosrow, and Farhad, John; (third row) Abdul Reza (standing), Karima, Azim, Raumin, Manijeh, Laura, Iran; (fourth row) Geoff (standing), Kanon, Iran, Parissa, Mohamed, Goly, Niloofar, Sonia (behind), Yasi, and Maheen (standing); and (back row) Kristen, Nader, Amir, Vali, Diana, Beata, and an unidentified person. (Image by Massoud Rad.)

Four

SOCIAL AND CULTURAL ACTIVITIES AND ORGANIZATIONS

Iranians in Chicago have steadfastly preserved their cultural heritage through cultural and social gatherings, celebrations, and activities. Before the revolution of 1979, there were two distinct groups involved in organizing and celebrating cultural events. One was led by the Iranian Consulate General for the non-political Iranians living in Chicago, while the politically active anti-Shah Iranian students organized the other. In fact, many recall attending the cultural events held by the consulate while the anti-Shah students met them in protest. The consulate closed in 1979 in the aftermath of the hostage taking of American diplomats in Iran.

Before the revolution and for a few years in the early 1980s, various groups of Iranian students were organized into a number of different political factions. For most of the years before 1979, virtually all Iranian student groups were united in the Global Confederation of Iranian Students, a highly visible, vibrant, and effective umbrella organization that coordinated the anti-Shah activities and international campaigns of the Iranian students studying abroad. This organization is considered the largest and most effective of its type throughout the history of student movements in the world. Over the years, this organization became increasingly and overwhelmingly leftist in its orientation and direction. Nevertheless, internally it was a dynamic and participatory organization. "The Confederation," as it was referred to by students, began to disintegrate in the mid-1970s.

Students, upon their arrival in Chicago, were approached by the recruiters of various student factions. Most would join repective groups and become active in relentless anti-Shah activities, including participation in regular study group sessions, meetings, dusk-to-dawn discussion sessions, demonstrations in Downtown Chicago and other cities, political, cultural and artistic productions, and preparing and distributing anti-Shah publications and literature. Besides this, many of the students worked in order to maintain their own needs, pay for their tuition, and contribute to the anti-Shah movement. This was especially true for Chicago during the summers as a large number of students from Midwestern and other cities in the United States came to Chicago for its greater job opportunities, and also because of its centrality for student political activism. Over the years, a number of locations, called "Iran Houses," were rented in Chicago as the Iranian student centers. As for other locations, the YMCA on Wabash Avenue and the University of Illinois Chicago, were two major centers for the events held by Iranian students.

Most of these students developed strong camaraderie, and a good number of them have maintained strong friendships and social bonds to this day. Many of these students returned to Iran after the revolution; some were imprisoned and/or killed there before, and especially after, the revolution. Quite a few of them returned to the United States and Chicago disillusioned after their dreams for a democratic Iran were shattered by the harsh reality of the Iranian political situation. While keeping strongly with their ideals of youth and years of struggle, they increasingly turned their attention away from activism and became more concerned about the

realities of raising their families or dealing with the needs of their personal lives.

The Islamic Revolution of 1979 resulted in the largest exodus of Iranians from Iran. Not since the Arabs' invasion of Iran and the Fall of the Sasanian Dynasty in seventh century, had so many Iranians left Iran. A main reason for the large immigration of Iranians to the United States was due to the nature of the revolutionary regime in Iran. The Islamic Republic was not only anti-Western, it was also against ancient Iranian identity and culture. For a concrete example, in the first years of revolution, the Islamic regime vigorously opposed celebrating Nowrouz and banned Chahr-Shanbeh Souri—a Persian tradition from Iran's Zoroastrian times—calling it a pre-Islamic pagan ceremony. Furthermore, Iranians in the United States and Chicago experienced duress as a result of the hostage crisis on November 6, 1979, in which 52 American diplomats were taken hostage and subsequently held for 444 days in Iran. This event shed a negative light on Iranians everywhere, especially in the United States. Feeling under siege, most Iranians throughout the world, including Chicago, became increasingly aware of their precarious situation and recognized that the way to counter these developments was through unity and sharing their cultural heritage. This was especially important as an increasing number of Iranians had families here and needed to provide cultural support and identity for their children.

Thus began the rise of cultural associations and societies in Chicago and elsewhere. Most of these non-political and non-religious organizations were mainly intent on holding Iranian ancient celebrations of Nowrouz, Tiregan, Mehregan, Yalda, Sadeh and Chahr-Shanbeh Souri. A few of these organizations were dedicated to Persian language and culture. Others were dedicated to holding social, political, historical, literary, and artistic talks, exhibitions, and conferences. Some of these events were held on a regular basis, such as Persian poetry nights, while others were held as major national and international seminars. A number of notable individuals and groups also held dance and music events at which mainly pre-revolutionary pop singers performed.

Overall, since the early 1980s, a multitude of cultural and social organizations, Persian language schools, and programming committees have been holding more than 500 events in Chicagoland. There have also been radio and television programs which, unfortunately, did not last due to the lack of funds. There were and are a number of different community publications, such as *Naveed*, *Khaneh*, *Jarchi*, the newsletter of the Pars Cultural and Educational Society, and several yellow pages. Currently, there are also a number of listservs and web sites for the community.

Pictured above is a pre-1979 celebration gathering of Iranian students sponsored by political organizations, c. 1977. (Courtesy of A.N.)

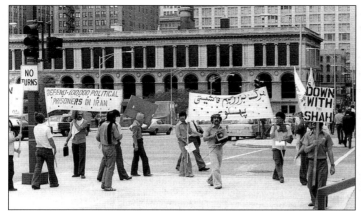

Students demonstrate against the Shah in Downtown Chicago, c. 1976. Beginning in the mid-1960s, through the 1970s, and up until the revolution of 1979, anti-Shah demonstrations by Iranian students abroad, including in Chicago, were typical scenes in most major metropolitan areas of the world. (Courtesy of A.N.)

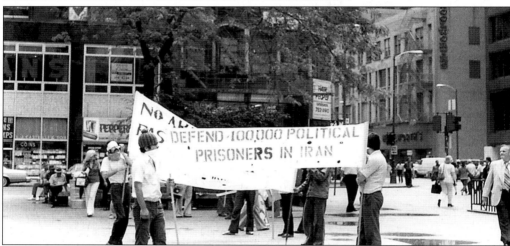

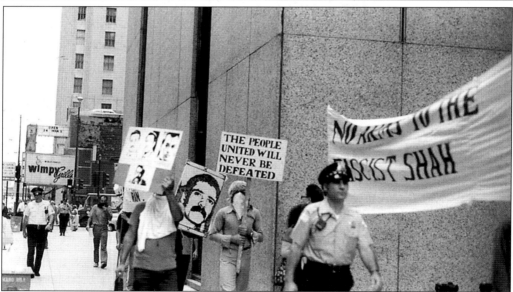

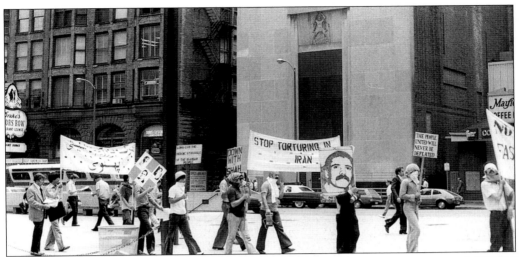

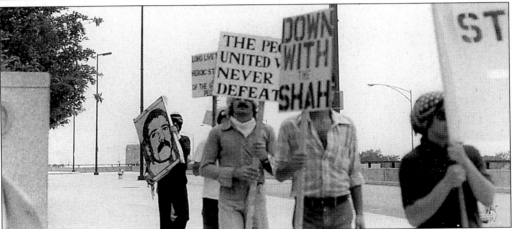

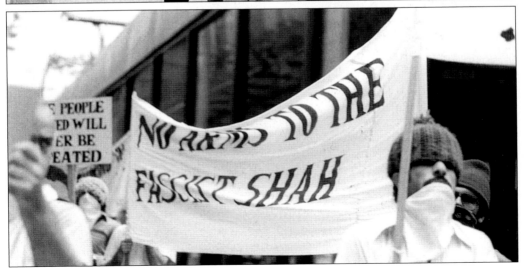

This site at Granville Avenue and Broadway Street was used as an "Iran House" by Iranian students from the 1960s through the early 1980s. Students paid dues to maintain the Iran Houses. (Courtesy of Ario.)

This former Iran House was located at 8848 Glenwood Avenue. (Courtesy of Ario.)

This space on Greenleaf Avenue also served as an Iran House at one time. (Courtesy of Ario.)

The Nima Cultural Institute at 7017 Glenwood Avenue was founded in 1987 and lasted physically for two-and-half years. Nima started a library, provided language and art lessons to children and adults, and held a variety of talks on Iran-related topics. The founders of Nima were Simin and Dr. Afra Shekarloo, Manijeh Marashi, Sorraya Sullivan, and Dr. Mohammad Tavakol Targhi. They were assisted by many volunteers, including Ario Mashayekhi and Mrs. and Dr. Keshavarzian. After its location closed, Nima continued to have a strong presence in Chicago through its programming until the mid-1990s. Beginning with the closing of the Nima building in 1989, new volunteers were mainly responsible for more than 40 Nima-sponsored events. These individuals included the authors of this book, Dr. Mohammad Tavakol Targhi, Dr. Hossein Birjandi, Nahid Zahedi, Mohammad Reza Saeed, Dr. Shafigheh Amir-Soltani-Saeed, Ali Bahrami, Mrs. Mahin and Dr. Hossein Ghanbari, Dr. Cyrus Amir-Mokri, Dr. Roya Ayman, Dr. Saba Ayman-Nolly, and many others. (Courtesy of Ario.)

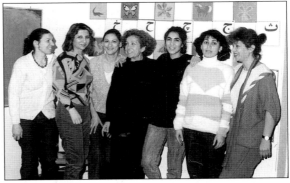

Right: Shown here are a group of Persian language teachers from the Nima Cultural Institute, *c.* 1988. Sorraya Sullivan and Simin Shekarloo (third and fourth from the left) were two of the institute's founders. (Courtesy of Manijeh Marashi.)

This 1988 photograph shows Manijeh Marashi, a founder of the Nima Cultural Instiute. (Courtesy of Manijeh Marashi.)

This May 1989 talk, held at the University of Chicago was sponsored by Nima. Panelists, from left to right, are: Dr. Changiz Pahlavan (a writer living in Germany), Dr. Mohammad Tavakol Targhi (a professor at Illinois State University and cofounder of Nima), and Dr. Ahmad Ashraf (professor of sociology). (Courtesy of the Akbari Family.)

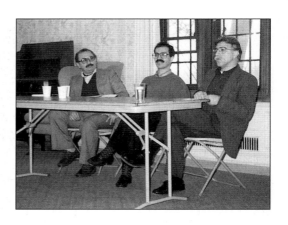

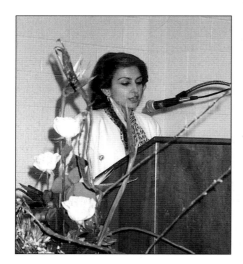

In 1990, the Nima Cultural Institute held a conference on the topic of Iranian women titled "Veiled and Unveiled Images." This conference, held at Northeastern Illinois University, was the first of its kind in the United States and included many nationally and internationally known speakers, including Dr. Farzaneh Milani, professor of Persian literature at the University of Virginia. (Courtesy of the Akbari Family.)

Dr. Afsaneh Najm Abadi, currently at Harvard University, also participated in the conference. (Courtesy of the Akbari Family.)

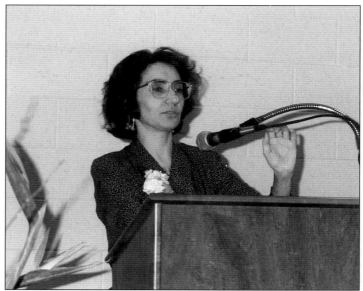

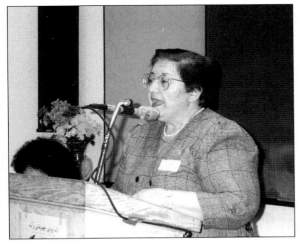

Mrs. Lily Ayman Ahi of Chicago gives a talk at the Conference on Iranian Women. Mrs. Ayman Ahi, a Persian language expert and author, is an integral part of the educational experience of most Iranians living in the United States; she was the principal author of the elementary Persian books which were read by all elementary students in Iran in the years before the revolution. (Courtesy of the Akbari Family.)

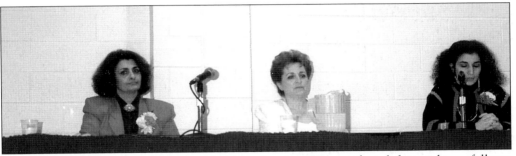

Pictured is another panel at the Conference on Iranian Women, from left to right, as follows: Mrs. Mahin Ghanbari, Ms. Mahmehr Golestaneh (a famous, Dallas-based Iranian painter), and Dr. Saba Ayman-Nolly from Northeastern Illinois University. (Courtesy of the Akbari Family.)

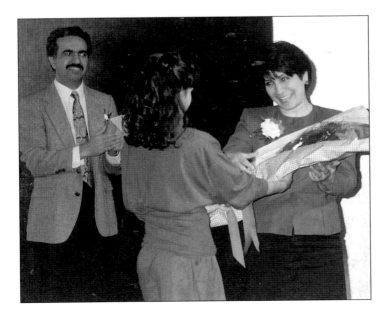

Ms. Soudabeh Yeganeh (right) receives flowers of appreciation during the recognition program of the Conference on Iranian Women held by Nima Cultural Institute. Ms. Yeganeh is one of the exemplary women business owners in Chicago. To the left is Professor Rasoul Afifi of Northeastern Illinois University. (Courtesy of the Akbari Family.)

Women members of the Pars Cultural and Educational Society hold their exhibition in Downtown Chicago, c. 2002. Pictured, from left to right, are: Mrs. Vajiheh Chinechian, Mrs. Shahla Afshar, Mrs. Alieh Behnia, and another colleague. As this and many other pictures show, Iranian women have played the most critical role in preserving the Iranian culture and traditions in their families and in the community. (Courtesy of Shahla Afshar.)

Dr. Mahmoud Hashemi, the founding president of the Pars Cultural and Educational Society, presents a recognition award to Mr. Farazandeh c. 1988. (Courtesy of Shahla Afshar.)

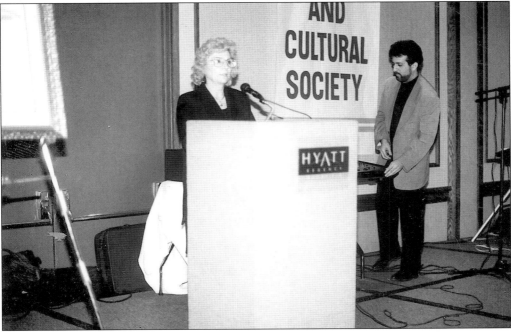

Mrs. Monireh Hashemi gives a talk at a gathering of the Pars Cultural and Educational Society c. 1995. Dr. and Mrs. Hashemi were most kind to any Iranian they came to know. They often hosted gatherings at their home and regularly invited their friends to dinner on Wednesday evenings or took them out to Drury Lane for a Sunday brunch. (Courtesy of Shahla Afshar.)

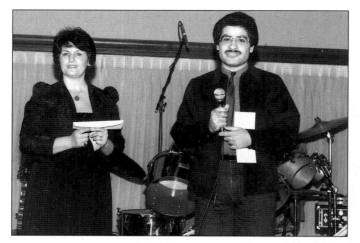

Mrs. Minoo Sohaey, president of the Iranian Cultural Society, presents a scholarship to a medical student in March of 1984. In the Iranian tradition of Marefat, responding to kindness and friendship, this student contributed the amount back to the society upon the completion of his education. (Courtesy of the Iranian Cultural Society.)

Dariush, one of the most popular singers among Iranians, performs at a Northeastern Illinois University concert organized by the Abtahi brothers c. 1995. (Courtesy of the Akbari Family.)

The late Vigen, a widely popular pre-revolutionary pop performer, sings for an Iranian Cultural Society Nowrouz party in March of 1984. (Courtesy of the Iranian Cultural Society.)

Pictured at right are Ahmad Nabizadeh, a singer living in California, and Abolfazel Shansi, a Chicago-based musician, c. 1990. (Courtesy of Ario.)

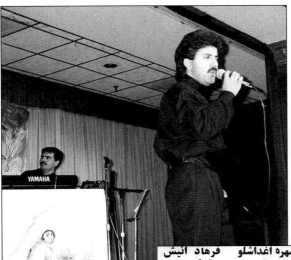

Mr. Shansi accompanies as Mehrdad sings in one of their many Chicago concerts. From 1976 to 1979, Mr. Shansi was a student in Chicago. In 1979, he traveled home to Iran, but returned to Chicago in 1986. From then until 1993, Mr. Shansi was involved in numerous entertainment and cultural events. He later resumed his studies, graduating from UIC with an M.S. degree in electrical engineering, and is currently the chief controller at IDAK Manufacturing Corporation. (Courtesy of Ario.)

This play featured Shohreh Aghdashlou, 2003 Oscar nominee for best supporting actress based on her performance in *The House of Sand and Fog*. She costarred in the film with Ben Kingsley and Jennifer Connelly. (Courtesy of Sohrab Abtahi.)

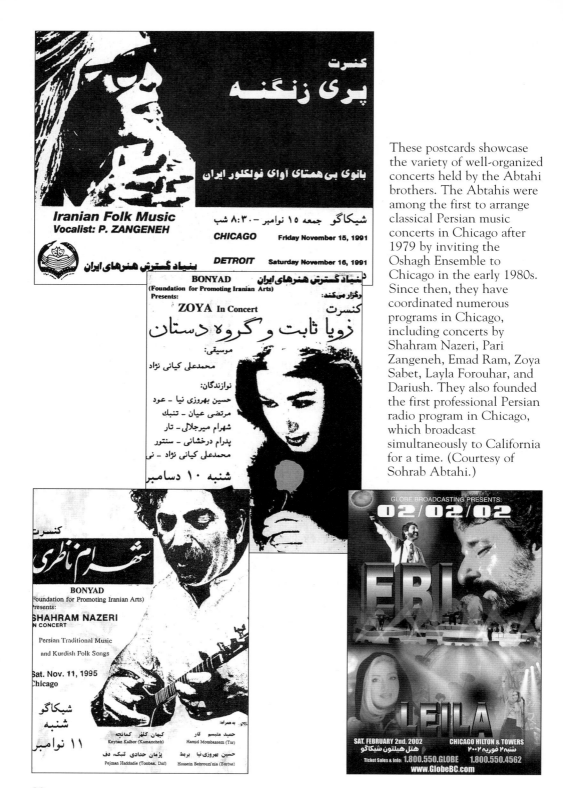

These postcards showcase the variety of well-organized concerts held by the Abtahi brothers. The Abtahis were among the first to arrange classical Persian music concerts in Chicago after 1979 by inviting the Oshagh Ensemble to Chicago in the early 1980s. Since then, they have coordinated numerous programs in Chicago, including concerts by Shahram Nazeri, Pari Zangeneh, Emad Ram, Zoya Sabet, Layla Forouhar, and Dariush. They also founded the first professional Persian radio program in Chicago, which broadcast simultaneously to California for a time. (Courtesy of Sohrab Abtahi.)

Right: Amnesty International has been a constant ally of Iranians defending human rights in Iran, both before and after the revolution of 1979. Here, Nancy Bothne, then director of the Amnesty International Midwest Office, speaks before a mainly Iranian group in defense of Mr. Faraj Sarkoohi, a political prisoner in Iran, *c.* 1996. (Courtesy of the Akbari Family.)

Left: Mrs. Farideh Zebarjad Sarkoohi speaks on behalf of her imprisoned husband, Mr. Faraj Sarkoohi. She toured many cities in Europe and the United States in defense of her husband. She succeeded in winning his freedom. (Courtesy of the Akbari Family.)

Right: Dr. Mohsen Ghaemmagham, M.D., (at left) a one-time resident of Chicago now living in New York, speaks on Iranian politics *c.* 2001. Dr. Mohammad Khoshnood (at right), a Chicago dentist chairs the session. (Image by Amir Noormandi. Courtesy of d'Last Studios.)

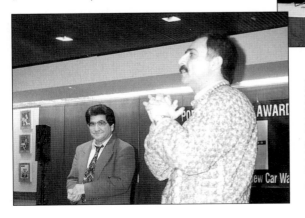

Dr. Nemat Mirzazadeh (Azarm), a well-known Iranian poet, is introduced by Dr. Mehdi Harandi, also a poet and head of graduate programs in computer science at the University of Illinois–Champaign. This Iranian Cultural Society event was held at Glenview Library in the late 1990s. (Courtesy of the Akbari Family.)

81

In May 2001, an unprecedented international academic conference was held at Northeastern Illinois University in commemoration of the 50th anniversary of Dr. Mohammad Mossadegh's government in Iran. This conference was organized by Dr. Houshang Keshavarz Sadr, Dr. Mahmoud Enayat, and one of the authors of this book, Hamid Akbari. Pictured, left to right, are Dr. Keshavarz, Dr. Cyrus Bina, and Dr. Mahmoud Enayat. (Courtesy of Ario.)

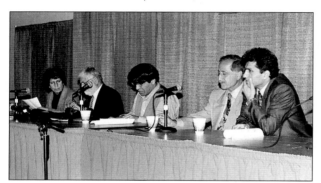

This conference panel focused on a comparative review of the student movement in Iran. Panelists, from left to right, are: Simin Berelian, Dr. Siakzar Berelian, Dr. Mehrdad Darvishpour, Dr. Bagher Samsam, and Gholamreza Mahajeri Nejad. (Courtesy of Ario.)

An unprecedented professional photo exhibit of the Mossadegh Era proved to be an important feature of the conference. This exhibition was designed and presented by Mr. Amir Noormandi of d'Last Studios. Ario Mashayekhi assisted with the set up. (Courtesy of Ario.)

STATE OF ILLINOIS

EXECUTIVE DEPARTMENT

Proclamation

WHEREAS, Mohammad Mossadegh, Mahatma Gandhi, and Nelson Mandela are national heroes for Iran, India, and South Africa, as well as international symbols of perseverance and civility and advocates of justice and democracy; and

WHEREAS, George Washington and Thomas Jefferson in the United States and Mahatma Gandhi in India led the fight for Independence from Britain, and Mohammad Mossadegh led the Iranian movement against the British colonialism in achieving the nationalization of the Iranian oil; and .

WHEREAS, for the occasion of the 50th anniversary of democratic election of Premier Dr. Mohammad Mossadegh, Northeastern Illinois University in Chicago is hosting a conference titled "Mossadegh and the future of Iran"; and

WHEREAS, numerous scholars and experts of Iran, Mossadegh, and Oil and British Colonial Politics will present their views to the conference from four different continents and various American universities; and

WHEREAS, many Iranian-American scholars and scientists contribute to our educational and research institutions as faculty members, department chairs, and deans at Northeastern Illinois University;

THEREFORE, I, George H. Ryan, Governor of the State of Illinois, proclaim May 2, 2001, as DR. MOHAMMAD MOSSADEGH DAY in Illinois.

In Witness Whereof, I have hereunto set my hand and caused the Great Seal of the State of Illinois to be affixed.

Done at the Capitol, in the City of Springfield, this ___FIRST___ day of ___MARCH___, in the Year of Our Lord two thousand and ___ONE___, and of the State of Illinois the one hundred and ___EIGHTY-THIRD___

SECRETARY OF STATE

GOVERNOR

May 2, 2001 was declared Dr. Mohammad Mossadegh Day in Illinois, after the importance of the Mossadegh conference was brought to the attention of the governor's office. Governor George Ryan issued the historic proclamation in commemoration of the 50th anniversary of the Mossadegh Government in Iran. Mr. Noormandi was integral in the genesis of this proclamation.

During an emotional and nostalgic part of the conference, participants listened to the words of Mr. Nosratollah Amini (standing with walker), who was Tehran's mayor for a period of time during Dr. Mossadegh premiership (1951–1953) and later his personal attorney. Mrs. Badri Shayegan (in wheelchair) also spoke; she was wife of Dr. Ali Shayegan, a National Front Member of the Parliament during Mossadegh Era and a close Mossadegh ally. (Courtesy of Ario.)

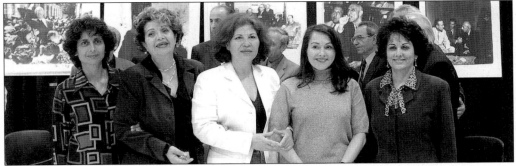

Some of Chicago's intellectual Iranian women gather at the conference, from left to right: Mehrnaz Saeed-Vafa, Manijeh Marashi, Mansoureh Saboori, Valentine Moghadam, and Janet Afary. Ms. Mansoureh Saboori is an Iranian filmmaker who was based in Chicago from early the 1990s until 2000. She now lives in Boston. (Image by Amir Noormandi. Courtesy of d'Last Studios.)

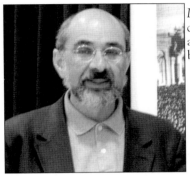

Left: Dr. Evrand Abrahamian, City University of New York distinguished professor of history and author of numerous articles and books on Iran, spoke at the conference. (Image by Amir Noormandi. Courtesy of d'Last Studios.)

Right: Dr. Nemat Mirzazadeh, a Mossadegh Conference panelist, confers with Mr. Mohammad Arasi, a journalist and public speaker based in Chicago. (Courtesy of Ario.)

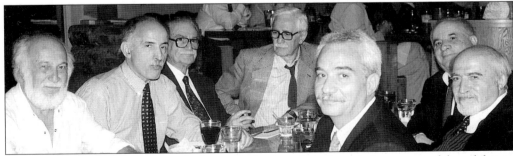

The Mossadegh Conference was the largest gathering of Iranian scholars, many of them lifetime friends, who spoke on this important subject in Iran's history and politics. Here they enjoy their social hour together at Cy's Crab House on Ashland Avenue, which graciously supported the conference through its able manager, Mr. Masoud. Pictured, from left to right, are: Dr. Mansur Farhang (Bennington College), Dr. Abdolkarim Lahidji (human right lawyer, Paris), Mr. Ali Shahandeh (legal scholar, Sweden), Mr. Iraj Pezeshkzad (writer), Mr. Esna Ashari (England), Dr. Mahmoud Enayat (journalist and editor of Negin), and a friend. (Courtesy of Ario.)

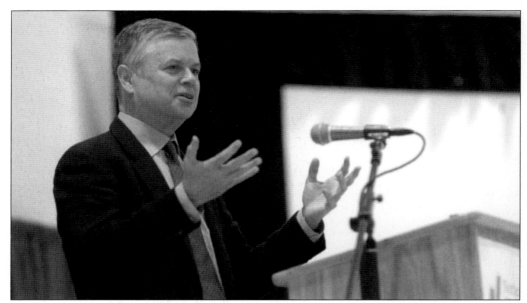

In November 2003, another unprecedented academic conference was held at Northeastern Illinois University on the 50th anniversary of the coups that toppled the Mossadegh Government in Iran and the Arbenz Government in Guatemala. A New York Times article by Stephen Kinzer, a conference participant, highlighted the conference themes and conclusions with this title: "Iran and Guatemala, 1953–1954: Revisiting Cold War Coups and Finding Them Costly." Here, Mr. Kinzer gives a keynote speech on the first night of the conference. Mr. Kinzer is the author of a recent book on Iran, *All the Shah's Men*. (Courtesy of Northeastern Illinois University.)

Northeastern Illinois University has been the leading university in Chicago in sponsoring programs and conferences on themes related to Iran since 1990. Much gratitude is owed NEIU President Dr. Salme H. Steinberg (right), and Dean of Academic Development and Affirmative Action Officer Dr. Murrell J. Duster (left). Their visionary and supportive style of leadership branches to all communities of Chicago and Illinois. (Courtesy of Northeastern Illinois University.)

Ms. Forouzan Arasi (at left) and the honorable Dr. Saeid Fatemi with Dr. Fariba Zarinehbaf (right), from Northwestern University's history department, at the Iran and Guatemala Conference. Dr. Saeid Fatemi is professor emeritus of literature and philosophy at Tehran University. He is author of innumerable articles and books and was Dr. Mohammad Mossadegh's translator in the Hague in 1952. His uncle, Dr. Hossein Fatemi, served as Dr. Mossadegh's foreign minister in 1953 and was executed after the coup against Mossadegh. Dr. Fatemi is the last living person who was in Mossadegh's residence on the fateful day of August 19, 1953. (Courtesy of Northeastern Illinois University.)

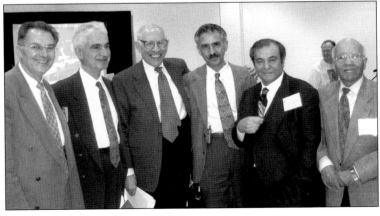

Captured here are joyful moments during the Iran and Guatemala Conference. (Courtesy of Northeastern Illinois University.)

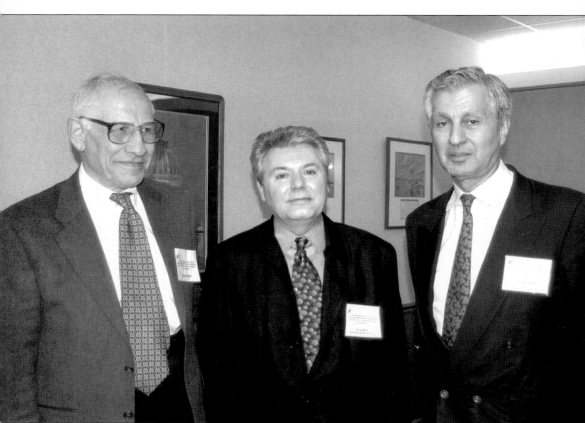

Shown here are conference presenters, from the left: Dr. Fatemi, Dr. Cyrus Bina (a professor at the University of Minnesota–Morris and prolific scholar and poet), and Dr. Farhad Diba (a Spain-based researcher and author, and nephew of Dr. Mossadegh). Dr. Bina has been most helpful to two conferences held on Mossadegh at Northeastern Illinois University. (Courtesy of Northeastern Illinois University.)

Memory & Estrangement

THE TALL SHADOWS OF THE WIND, November 12

In the fall of 1989, the Film Center at the Art Institute of Chicago (later the Gene Siskel Film Center), in cooperation with the Nima Cultural Institute, founded the annual Iranian film series. The first year included films made both before and after the revolution and two films by filmmakers in exile. After the first year, the films were exclusively from Iran, and later the name of the annual series changed to Festival of Films from Iran. (Courtesy of the Gene Siskel Film Center.)

Left: Parviz Sayyad speaks at the Film Center following the screening of his film, *Mission*, as part of the First Iranian Film Festival in 1989. (Courtesy of the Akbari Family.)

Left: Bahram Bayzaei, a top Iranian filmmaker and playwright, has been a guest of the Festival of Films from Iran. Many of Bayzaei's films have been banned in Iran. (Courtesy of Mehrnaz Saeed-Vafa.)

Right: Tahmineh Milani (at left) and Farima Farjami (at right), both leading filmmakers from Iran, are shown at the Gene Siskel Film Center during one of the Festival of Films from Iran screenings. (Image by Amir Noormandi. Courtesy of d'Last Studios.)

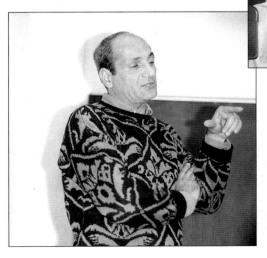

Left: Filmmaker Masoud Kimiavi was a guest of the first Festival of Iranian films, *c.* 1989. (Courtesy of Mehrnaz Saeed-Vafa.)

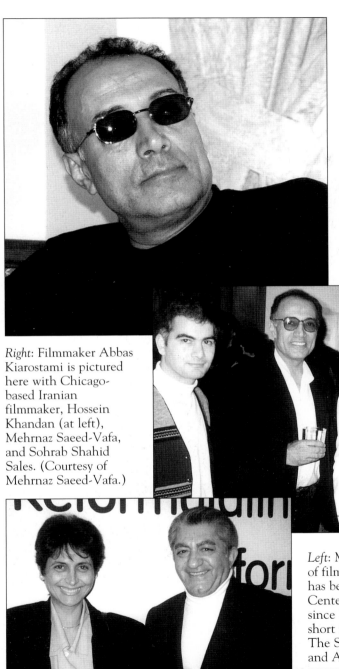

Left: Abbas Kiarostami is a world-famous Iranian filmmaker. For his works, he has received numerous international film festival awards and recognition, including the Golden Palm from Cannes. His simple, yet deep and penetrating, style relies on ordinary people acting in their own stories and has broken unprecedented ground in filmmaking. He came to Chicago during one of the Annual Festival of Films from Iran held at the Gene Siskel Film Center.

Right: Filmmaker Abbas Kiarostami is pictured here with Chicago-based Iranian filmmaker, Hossein Khandan (at left), Mehrnaz Saeed-Vafa, and Sohrab Shahid Sales. (Courtesy of Mehrnaz Saeed-Vafa.)

Left: Mehrnaz Saeed-Vafa, a professor of filmmaking at Columbia College, has been a consultant to the Film Center for its Iranian Film Series since 1989. She has made several short films including Far from Home, The Silent Majority, Ruins Within, and A Tajik Woman that have been screened at many international film festivals. Her book Abbas Kiarostami, coauthored with Jonathan Rosenbaum, was published in 2003. She is shown here with Ezzatollah Entezami, a famous Iranian actor. (Courtesy of Mehrnaz Saeed-Vafa.)

Aryana Farshad's films were shown in the first Iranian Diaspora Cinema Festival held in Chicago in April 2003. (Image by Amir Noormandi. Courtesy of d'Last Studios.)

Pershang Sadegh Vaziri screened one of her films at the 2003 Iranian Diaspora Cinema Festival as well. (Image by Amir Noormandi. Courtesy of d'Last Studios.)

This photograph of prominent Iranian filmmaker Bahman Farmanara was taken in November 2002. (Image by Amir Noormandi. Courtesy of d'Last Studios.)

Right: In 1988, the University of Chicago hosted the annual gathering of the Center for Iranian Research and Analysis (CIRA). Shown here are three of the participants of the conference, from left to right: Dr. Khojandi, Esmail Khoei (renowned poet), and Mr. Ali Sajjadi (from Washington D.C.). Another important conference on the well-known Iranian woman poet, Parvin Etesami, was held by the University of Chicago in the late 1980s. (Courtesy of Ario.)

Left: Manuchehr Mohammadi poses with Mohammad Fathi *c*.1998. As the general secretary of the pro-democracy Union of Iranian University Students and Graduates, Mr. Mohammadi came to the United States to speak at universities. He returned to Iran and was imprisoned after the July 1999 student uprising in Iran. (Courtesy of the Akbari Family.)

Right: Out-of-town speakers have been a treasured addition to the Iranian community. An after-event gathering for poet Manuchehr Atashi, held by the Nima Cultural Institute at Cy's Crab House, included, from left to right: Hossein Birjandi, Bahram Mobasheri, Atashi, and Atta Kosari. (Courtesy of the Birjandi Family.)

This 1999 photograph was taken at the conclusion of an Evanston Library event for Esmail Khoei, a prominent poet (seated). (Courtesy of Ali Babazadeh.)

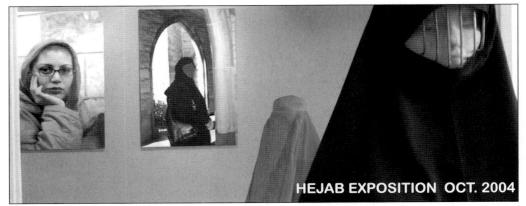

HEJAB EXPOSITION OCT. 2004

An unprecedented Hejab (veil) photo exposition was held in October 2004 by Mr. Amir Noormandi. The exposition took a critical look at the forms and functions of the veil in Iran. (Image by Amir Noormandi. Courtesy of d'Last Studios.)

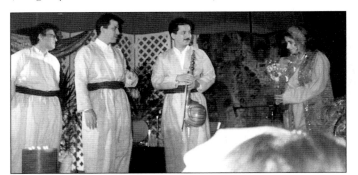

The Kamkars Persian Music Ensemble performed during a Nowrouz program in 1999. (Courtesy of Ali Babazadeh.)

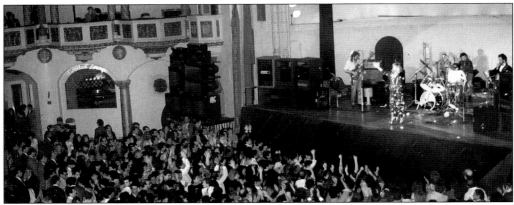

A post-1979 record of 2000 people attended a concert at the Aragon Theatre in Chicago. Hayedeh was one of the singers. This concert served as a fundraiser for a planned Iranian television program in Chicago, to be led by Mr. Cyrus Sadeghi. Later on, Mr. Javad Saffar-Zadeh continued production of a television show on WCIU-26. It did not survive financially. Other than the longest-lasting Iranian radio program, Radio Iran, there were two other programs that broadcast for a few years. One was Radio Sahel, managed by Mr. Vania Pazand; the other was Radio Vatan, managed by Mr. Najaf Hossieni. (Image by Amir Noormandi. Courtesy of d'Last Studios.)

94

Five

WELL-KNOWN VISITORS

A highlight of life for Iranians in Chicago has been to host, see, and hear a number of well-known political, literary, cultural, and artistic Iranian personalities who briefly visited Chicago. Some of these Iranians are well known in the world, such as Ahmad Shamlu, the renowned Iranian poet who gave a talk at the University of Chicago in 1990. Others include Shapour Bakhtiar, former prime minister of Iran; Ehsan Yarshatar, the renowned Iranian literary figure at Columbia University and the founder of Iranica, the grand encyclopedic project on Iran and Iranians; Abbas Kiarostami, the world-renowned Iranian filmmaker who attended the Iranian Film Festival at the Gene Siskel Film Center; Reza Pahlavi, son of the former Shah of Iran; and Azar Nafisi, the writer of the widely-read novel, *Reading Lolita in Tehran*.

There have been other guests, better known within the Iranian community, such as Agha Bozorg Alavi, the famed writer of the classic Persian novel *Her Eyes*; Iraj Pezeshkzad, well-known writer of another classic Persian novel, *Dear Uncle Napoleon*; Hadi Khorsandi, one of the premier Iranian satirists; Behrouz Vossuoghi, the top actor in Iran before the revolution; and Mahmoud Dowlatabadi, a famed Iranian novelist.

While most of these well-known Iranians stayed in Chicago for only a few days, a few remained in the city for a longer period of time. Prominent among this group was Dr. Amir Houshang Keshavarz Sadr, who lived in Chicago for more than a year between 1990 and 1991 and has visited Chicago periodically since that time. Dr. Keshavarz Sadr, an authority on the Iran's rural areas and a former member of Iran's National Front Executive Council, first came to Chicago in April 1990 for a talk at the University of Chicago. In the fall of 1990, he returned to Chicago to assist with the establishment of a Persian library, named Dehkhoda (a giant literary figure in Iran), located at 3224 West Bryn Mawr Avenue. During his one-year stay in Chicago, he organized a number of gatherings in which most of the Iranian cultural and social organizations came together for exchange and unity. While Dehkhoda Library received generous support, it did not survive economically, and became yet another failed attempt to provide a physical place for the gathering of Iranians.

Another important figure who lived in Chicago for a year was Sohrab Shahid Sales, the famed Iranian filmmaker, who pioneered the style of filmmaking based on filming the lives of ordinary people. Shahid Sales lived in Evanston for more than a year before his death in July 1998. Professors Ahmad Karimi Hakkak and Khosrow Shakeri have also taught in Chicago universities for short periods.

For large numbers of Iranians in Chicago, the presence of these well-known figures was a way of connecting with the homeland. They brought with them a sense of the homeland's vitality and the hope for her future. Others, such as Parviz Sayyad, creator and actor of the comic/satirical figure, Samad, responded to Iranians' nostalgia for happier times in Iran. Iranians in Chicago were ecstatic to see their favorite writers, actors, and artists so close in front of them. Most importantly, these Iranian figures brought with them yet another opportunity for many different Iranians in Chicago and the United States to come together, cherish each other, and evoke a nostalgic past—like the great Gatsby's story—so close in their grasp, yet so far in the past.

The late Ahmad Shamlu, the most well-known modern Iranian poet, came to Chicago for a talk at the University of Chicago in spring 1990. His presence stirred up Iranians in Chicago and all the surrounding cities and states. More than 700, a record number at any single literary program, attended his event. (Courtesy of the Akbari Family.)

Shamlu gives his autograph to one of the oldest Iranian student immigrants in Chicago, Mr. Reza Hosseini Tabrizi (right), while Mr. Shamlu's wife, Ida, speaks to Dr. Mohammad Tavakol Targhi of the Nima Cultural Institute. (Courtesy of the Akbari Family.)

Shamlu is shown here with Azadeh Akbari (the authors' daughter). Though he was asked not to kneel because of pain in his leg (which was amputated a few years later), he answered, "I kneel for all young souls." (Courtesy of the Akbari Family.)

Shown here is another image of Ahmad Shamlu. (Courtesy of the Akbari Family.)

Agha Bozorg Alavi, a well-known Iranian novelist and author of the widely-read novel *Her Eyes*, gave a Nima-sponsored talk to a packed Hall in the fall of 1989 at the University of Chicago. Agha Bozorg's talk on the subject of writing in exile resonated with the audience, most of whom had left Iran, probably for good. (Courtesy of the Akbari Family.)

Tears ran down most of the faces in the audience as Agha Bozorg was eloquently and emotionally introduced by Dr. Heshmat Moayyad, and as he spoke of the emotional wounds inflicted upon writers, like himself, who live in exile. (Courtesy of the Akbari Family.)

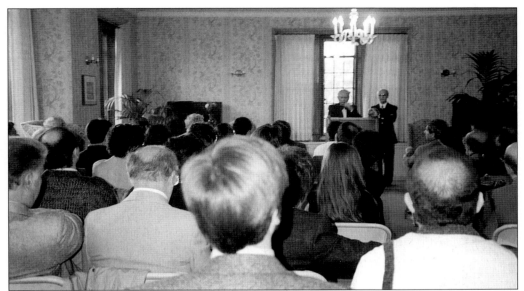

The audience listens attentively to Dr. Moayyad and Agha Bozorg Alavi. (Courtesy of the Akbari Family.)

Agha Bozorg Alavi and Mr. Hosseini Tabrizi first met at this event. Mr. Tabrizi's father, however, was in prison with Mr. Agha Bozorg Alavi when the two were made political prisoners by Reza Shah about fifty years previously. The incident was known in Iran as the imprisonment case of 53 Prisoners—the subject of a book by Bozorg Alavi. Mr. Tabrizi came to Chicago as a student in the late 1950s and was one of the most active members of the confederation. While in Chicago, he married his wife, Ellie, and they have a daughter, Afsaneh, who became quite selflessly active in the Iranian community. Mr. Tabrizi served the Iranian community by his many involvements until his family moved to Wisconsin in the late 1990s. (Courtesy of the Akbari Family.)

Dr. Shapour Bakhtiar, the last prime minister of Iran prior to the revolution of 1979, spoke to the Chicago Council on Foreign Relations in May 1983. Dr. Bakhtiar was a deputy labor minister in Dr. Mossadegh's second cabinet and later became a leader of the National Front. He was assassinated in Paris in August 1991. (Courtesy of the Chicago Council on Foreign Relations, Archives Division.)

Dr. Mahmoud Goudarzi, an Iranian journalist from Washington D.C., has been a frequent guest of the Iranian community in Chicago. A veteran of journalistic writing and a tireless activist for Iranian causes, he has been most helpful to many major events held in Chicago, including the two conferences on Dr. Mossadegh and his downfall. Among his talks to Iranians in Chicago, he spoke on Amir Kabir, a widely-respected nineteenth century Iranian premier under Nasser-e-din Shah. He also helped to organize two gatherings of Iranian activists in Lake Geneva (1998) and West Palm Beach (1999) along with Nasrin Almasi, Mohammad Tajdollati, and the first author of this book. Most notably, however, he has assisted in raising funds for the Historic Dr. Mohammad Mossadegh Leadership Fund at Northeastern Illinois University. This fund provides scholarships for students at Northeastern. Dr. Goudarzi is shown here at the 1991 Mossadegh Conference. (Image by Amir Noormandi. Courtesy of d'Last Studios.)

Sohrab Shahid Sales, who lived for a year in Chicago before he died in his Evanston apartment in July 1998, is considered among the most innovative and progressive filmmakers in the world. His groundbreaking style won him several international awards, including one from the Chicago International Film festival in the 1970s. (Image by Amir Noormandi. Courtesy of d'Last Studios.)

Before coming to the United States, Sales lived in exile in Germany and made over ten German-language films. Some of his works include *A Simple Accident*, *Lifeless Nature*, *Utopia*, and *Roses for Africa*. His last screenplay, *Love in Silence*, which he had dedicated to a Palestinian grocery owner, was never returned to him by a ghost translator! His untimely death in Chicago saddened many Iranians here. (Courtesy of Ezzat Goushegir.)

Mohammad Mokhtari, a literary critic, visited Chicago in the mid-1990s. A few years later, he was assassinated in Iran during a series of killings referred to as the "Serial Killings." (Courtesy of Ali Babazadeh.)

Arash Forouhar, resident of Germany, speaks in memory of his parents, Dariush and Parvaneh Forouhar, who were among the most prominent of those assassinated in Iran for their political activism in 1998. They were disciples of Mossadegh and leaders of the Iran Nation Party. (Courtesy of the Akbari Family.)

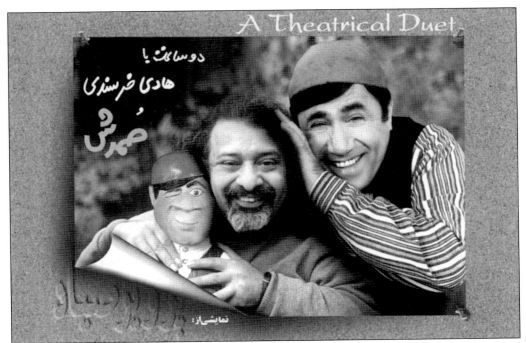

The stage play *Hadi Khorsandi and his Samad*, acted by Parviz Sayyad and Hadi Khorsandi, proved to be a memorable event in Chicago. Parviz Sayyad, creator of the pre- and post-revolutionary comic/satirical figure Samad is a popular artist among Iranians everywhere, including Chicago. Hadi Khorsandi is a popular and prominent Iranian satire writer. Their two-hour program was filled with incessant laughter. (Courtesy of Parviz Sayyad.)

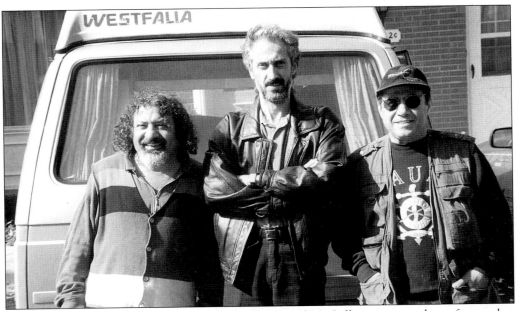

The day after their performance, Sayyad, Khorsandi, and Mr. Jaffari prepare to leave for another city, Columbus, Ohio, and another crowd of Iranians. (Courtesy of the Akbari Family.)

Right: Dr. Amir Houshang Keshavarz Sadr, who lives in exile in Paris, has been a frequent visitor to Chicago and lived in the city for a year and a half beginning in fall 1990. He made significant contributions to the intellectual and cultural life of Iranians in Chicago during this period and during his subsequent trips to Chicago. His residence was a small room at Dehkhoda Library. Here, he speaks at a Nima event at the University of Chicago in April 1990, when he first came to Chicago. (Courtesy of the Akbari Family.)

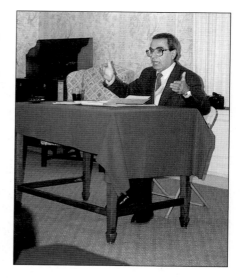

Left: The Dehkhoda Library at 3224 Bryn Mawr Avenue (founded by the authors of this book, later joined by Ario Mashayekhi) was an attempt by Iranians to provide a cultural center for their community in Chicago. Despite considerable support, financial difficulties forced closure in 1992. (Courtesy of Ario.)

The name Dehkoda, suggested by Dr. Keshavarz Sadr, refers to Ali Akbar Dehkhoda, one of the literary and social science giants of twentieth-century Iran. Among his innumerable contributions to Iranian culture is that of the *Dehkhoda Dictionary*, the first of its kind in Iran. Pictured here is a painting of Dehkhoda by Ario Mashayekhi. This painting was done at the Dehkhoda Library, where Ario and Dr. Keshavarz shared space (Courtesy of Ario.)

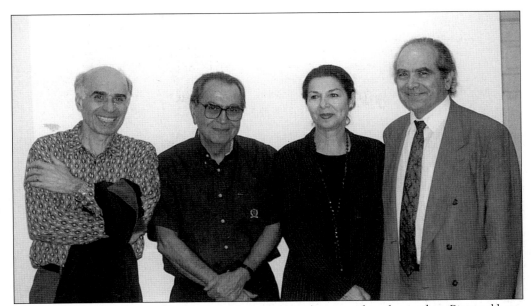

Dr. Keshavarz's presence in Chicago would always bring his many friends together. Pictured here, from left to right, are: Dr. Bahram Raofi, M.D., a strong supporter of cultural activities; Dr. Keshavarz; Dr. Nahid Razavi Raofi, M.D., an active member of Iranian cultural activities; and Dr. Afrasiab Shekalo, M.D., a prominent community member. (Courtesy of Ario.)

A lecture program was held for Ms. Malek Jahan Khazaei (center), an Iranian artist, writer, and filmmaker, at Dehkhoda Library, *c.* 1991. At left are Mrs. Mahin Ghanbari and Dr. Kamal Modir, and to the right are Mr. Amir Noormandi and Ms. Mehrnaz Saeed-Vafa. (Courtesy of Ario.)

Simin Behbahani, shown on the right, with Mrs. Eghbali (center) and Dr. Mahin Serry, M.D., came to Chicago twice during the 1990s. She is considered the most prominent living modern poet of Iran. Today, her famous poem, "I Shall Rebuild You Again, My Homeland," enjoys popular and widespread recitation in Iran, especially by students. In the 2004 Annual Poetry Night in Chicago (hosted by Mrs. Eghbali), a ten-year-old Iranian girl recited this poem. Dr. Serry and her husband, Dr. Cyrus Serry, are considered to be among the most benevolent and well-respected families in the Iranian community. (Courtesy of the Eghbali Family.)

Googoosh is the most popular and widely-known Iranian singer. In October 2000, after nearly 22 years of silent life in Iran, Googoosh went on a tour of Canada and the United States. Her events marked the largest gathering of Iranians in Chicago and elsewhere. In Chicago, 6,000 attended her concert at UIC Pavilion and sang with her as she and many members of the audience laughed and cried together. Googoosh is hugely loved by most Iranians, and she is also well-known in Iran's neighboring countries, especially Tajikistan, where she is idolized. A pre-revolutionary event in the mid-1970s, which included Googoosh and several other singers at McCormick Auditorium, brought together the largest gathering of Iranians in Chicago prior to 1979. A crowd of 3,000 participated in that event. The Abtahi brothers were the local organizers of the most recent concert, while Iran's Consulate General organized the first one. (Courtesy of Sohrab Abtahi.)

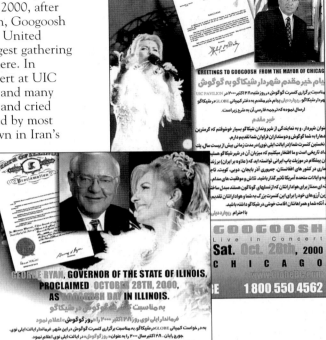

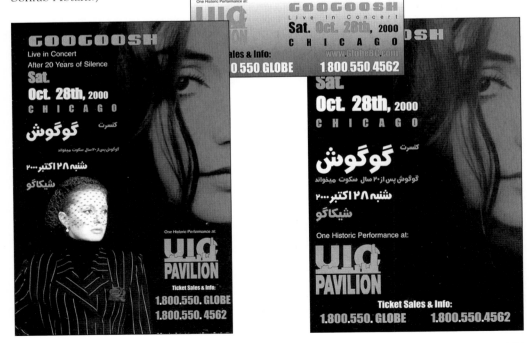

107

Master Tenor Mohammad Reza Shajarian (fourth from the right) is considered the pre-eminent traditional singer of Iran. His 1990 performance in Chicago was attended by over 700 people and is marked as a major Chicago event. He is the most well-known and highly-respected Iranian traditional singer. Invited by the Nima Cultural Institute, he performed at the University of Chicago. He is pictured here among enthusiasts. (Courtesy of the Birjandi Family.)

Mr. Shajarian (left) is pictured here with Mr. Reza Toulabi (right) and Mr. Gholam Toulabi, owners of Reza Restaurants. (Courtesy of Birjandi Family.)

Behrouz Vossoughi (fifth from the left) was the top male actor in Iran before the revolution. He came to Chicago for several programs, including the screening of his hit movie, *Caesar*, at the University of Chicago. Iranian immigrants remember him for his fine acting in other hit films as well, including *Tangsir* and *Gavaznha*. He currently lives in California. (Courtesy of Ali Babazadeh.)

Maestro Mohammad Reza Lotfi, a traditional Persian musician, has been a frequent guest in Chicago. His programs have always been well attended. (Courtesy of Ario.)

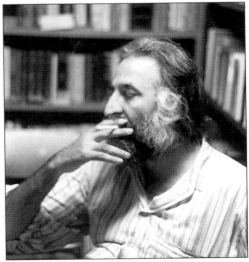

Mr. Lotfi is pictured here with Ario Mashayekhi. (Courtesy of Ario.)

Iraj Pezeshekzad, the famous satirist of Iran, spoke to a large crowd at the Alumni Hall of Northeastern Illinois University, c. 1997. He is best known for his English-translated widely-read Persian novel, *My Uncle Napoleon*. In that popular story, he presents a satirical critique of a prevalent Iranian mindset that everything wrong in Iran has something to do with British influence: "It's the work of the British." He is shown here in Downtown Chicago with his son, Bahman, who is a professional painter. This program was sponsored by the Committee on Seminars on Iran, a Morton Grove-based group which organized numerous programs in the 1990s through the early 2000s. The authors of this book were among the founding members. (Courtesy of the Akbari Family.)

Shown in this 2001 photograph, Mr. Parviz Dastmalchi is a prolific author on political subjects and an activist based in Germany. He is one of the survivors of the Mykonos Restaurant political killings in 1992 and gave a talk to the Committee for Seminars on Iran in the late 1990s. (Courtesy of Ario.)

Dr. Abdolkarim Lahidji spoke on the subject of Abbas Amir-Entezam, the longest-held political prisoner in Iran following the revolution of 1979. This event was held in 1998 by the Committee for Seminars on Iran. (Courtesy of the Akbari Family.)

Mehedi Khanbaba Tehrani, a veteran Iranian political activist living in Germany gave a talk sponsored by the Iran House of Greater Chicago in the fall of 1999. (Courtesy of the Akbari Family.)

Hassan Nazih, living as an exile in Paris, has been a frequent guest to Chicago. He was a ministerial level executive director of the Iran National Oil Company in the post-revolutionary government of Mehdi Bazargan. He is shown here in 1993. (Courtesy of the Akbari Family.)

Houshang Ebtehaj, a well-known Iranian poet, is shown here at a poetry event sponsored by the Iranian American Society. Next to him is Mr. Ali Babazadeh, a Chicago-based poet and social activist. (Courtesy of Ali Babazadeh.)

Left: Pictured here is the late Houshang Golshiri, *c*. 1992. A prolific Iranian writer, Golshiri was invited to Chicago by the Nima Cultural Institute. (Courtesy of the Birjandi Family.)

Right: Poet Manuchehr Atashi reads at the University of Chicago in a May 1993 event held by the Nima Cultural Institute. (Courtesy of Ali Babazadeh.)

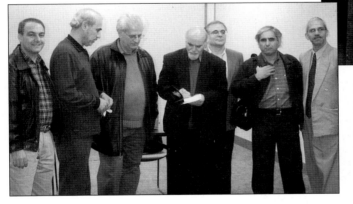

Left: Reza Baraheni (fourth from left) is a Canada-based Iranian novelist and literary critic. Here, he concludes a talk sponsored by the Iran House of Greater Chicago. (Courtesy of the Iran House of Greater Chicago.)

Dr. Ahmad Karimi Hakakk, professor of Persian literature at the University of Washington in Seattle speaks at the Evanston Library in an event sponsored by the Iran House of Greater Chicago, *c*. 2001. (Courtesy of the Iran House of Greater Chicago.)

Professor Ehsan Yarshater is one of the most widely respected and erudite literary academics of Iran. He is also the founder of the *Iranica*, the stupendous multi-volume encyclopedia of everything about Iran. He is a Columbia University distinguished professor emeritus and continues to work a full-time schedule on the *Iranica* and his other academic endeavors from his office at Columbia University. He has often visited Chicago. (Image by Amir Noormandi. Courtesy of d'Last Studios.)

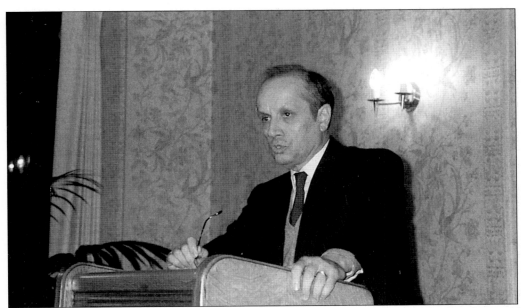

Professor Jalal Matini, former president of Mashhad University in Iran before the revolution of 1979, is a major literary writer and critic. He has been in exile in Washington D.C. since 1979 and is editor of the Iran Shenasi journal. In 1990, he gave a Nima Cultural Institue-sponsored talk on Ferdowsi at the University of Chicago. (Courtesy of the Akbari Family.)

Mr. Hassan Shahbaz, a well-known Iranian literary figure and the publisher of the well-regarded *Journal of Rahavard*, was invited to Chicago for a talk in the late 1990s. He is shown here with the late Abbas Radjaie (right) and Mr. Yadi Babapour, an Iranian social and cultural activist. (Courtesy of Ali Babazadeh.)

Azar Nafisi, the renowned Iranian writer of *Reading Lolita in Tehran* (a best seller for more than a year) and a professor at the School of Advanced International Studies at John Hopkins University, visited Chicago in the fall of 2002 to give a talk at the Chicago Humanities Festival. Here she is shown with her relative and the Iranian Cultural Society's secretary, Dr. Shahrzad Nafici. (Courtesy of Mehdi Nafici.)

Six

THE NEXT GENERATION

Moen-Ol Saltaneh (see Chapter One) probably never imagined living in Chicago beyond a few weeks, and many among the immigrant generation of Iranians still dream of returning to a democratic and prosperous Iran, even though they have made a home in Chicago. There is no doubt, however, that a large majority of the first generation of Iranians born and raised here have claimed Chicago and the United States as their permanent home, despite their love for Iran. The initial group of these first-generation Iranians are already between 25 and 35 years old. Many of them are married to other Iranians or non-Iranians and have their own children to whom they tell the stories of their grandparents who came from Iran.

This young and upcoming generation has already achieved spectacular success in Chicago and the United States. There are numerous medical doctors, engineers, lawyers, business professionals, computer analysts, chefs, filmmakers, fashion designers, construction contractors, musicians, and reporters. An exemplary young Iranian is Ms. Azin Salimi, born and raised in Chicago, who works for Doctors Without Borders in New York. There is a successful monthly gathering of young Iranian professionals called Shab Jomeh, which regularly meets in Chicago and other large cities throughout the United States and the world. Moreover, the young Iranians living in the U.S., like other young people, are well connected with each other through the internet.

A major, annual program which, until a few years ago, brought the immigrant and young generations together was the Iranian Cultural Society's Mother and Children (originally Mother and Daughter) Luncheon founded by Mrs. Minoo Sohaey and her associates, including the talented young Iranian, Ms. Neda Nabavi. This program, which began in November 1988 and continued through 2002, showcased successful young Iranians and their various achievements and experiences to younger Iranians; it was always well attended.

Many of these young people were impacted by the unfortunate and tragic hostage taking event of 1979. While they and their families opposed the act of hostage taking and were and remain law-abiding citizens of the United States, they were, most unfortunately, subjected to numerous abuses and discriminations in their schools; their parents were subjected to the same in their workplaces and society. Indeed, many of these children, out of fear for their safety, had to hide their identity, and many were beaten or threatened by their schoolmates. Meanwhile, most of the older generation and university students were scrutinized by the immigration officers and many were harassed by some members of the general public. A recent movie by Ramin Serry, *Maryam*, relates the story of an immigrant Iranian family caught in the events of this landmark crisis.

We close our words in this book confident that the young generation of Iranian-Americans continues to well-represent their rich Iranian culture and heritage, both ancient and modern, in the United States. With the rise of democracy everywhere in the world, there is a special opportunity for young Iranians to learn and celebrate the centennial anniversary of the Iranian Constitutional Revolution of 1906, a peaceful, thoughtful, and non-violent revolution that brought the first democratic government in the Middle East and mainland Asia.

Pictured are hosts and participants in the Iranian Cultural Society's annual Mother and Children Luncheon, from left to right: Ms. Mahsa Sherkarloo, co-host Mrs. Minoo Sohaey, public relations specialist and co-host Ms. Neda Nabavi, and filmmaker Mr. Ramin Serry.

Mr. Serry's main feature film, *Maryam*, was screened in all major U.S. cities in the early 2000s. The story portrays the social hardship faced by Iranians during the hostage taking of 1979, which lasted for 444 days. Many Iranian children of Ramin's generation were harassed. Those were hard years for all Iranians, especially the children. (Courtesy of the Sohaey Family.)

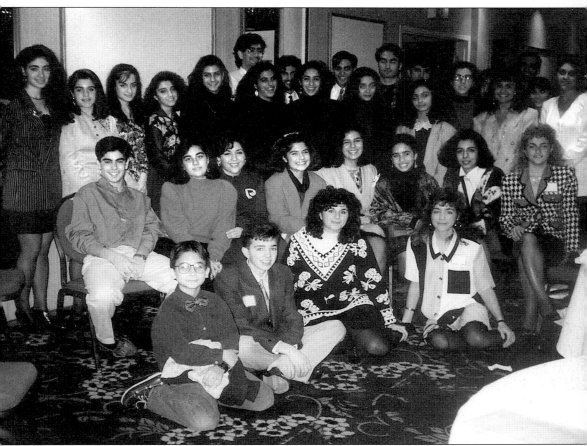

Iranian-American children and the youth of yesterday are today contributing to the United States as lawyers, accountants, medical doctors, artists, teachers, professors, social workers, and more. This picture was taken at the annual Mother and Children Luncheon of the Iranian Cultural Society, hosted by Mrs. Minoo Sohaey and her associates, c.1988. (Courtesy of the Sohaey Family.)

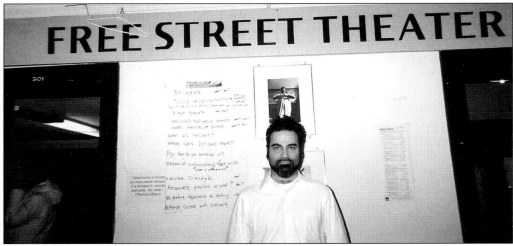

As shown in this 2004 picture, Robert Karimi is a school teacher and performing arts professional with an Iranian-Guatemalan-American background. He works with the Free Street Theatre in Chicago where he teaches inner-city teenagers about Iran's Hostage Crisis and other impacting world historical and political events. (Courtesy of the Akbari Family.)

Mr. Karimi has produced and performed a touching one-man show about the discrimination he experienced as a child during the hostage crisis. (Courtesy of the Akbari Family.)

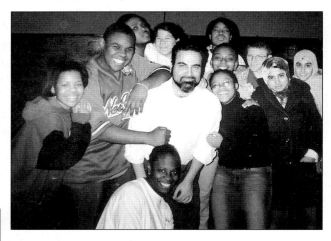

Pictured here is CBC-TV producer Hope Khosravi. She was the host of a 1996 Nowrouz celebration. (Image by Amir Noormandi. Courtesy of d'Last Studios.)

Sanaz Tabrizi, in Gilani traditional dress, presents a Persian artwork to Illinois First Lady Brenda Edgar in 1993. (Courtesy of the Illinois Ethnic Affairs Office and d'Last Studios.)

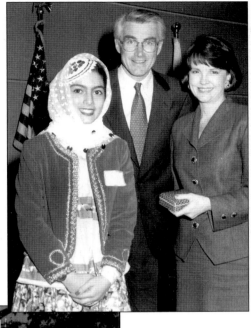

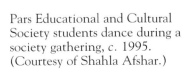

Students of the Pars Educational and Cultural Society pose at a society gathering, c. 1986. (Courtesy of Shahla Afshar.)

Pars Educational and Cultural Society students dance during a society gathering, c. 1995. (Courtesy of Shahla Afshar.)

The authors' son Kaveh Akbari (right) and nephew, Eamon Ghaziasgar, show their interest in serious matters, despite their young age, as they pose at the 2002 Iran–Guatemala Conference with Amy Goodman, renowned independent journalist and host of the Democracy Now program. Kaveh intends to be a political scientist, while Eamon is interested in social sciences. (Courtesy of Northeastern Illinois University.)

Left: In this 1992 image, Shirin Birjandi (at right) poses with renowned Iranian novelist Ms. Shahrnoosh Parsipour (center), and a friend. Ms. Parsipour became famous with the publication of her novels *Touba*, *The Meaning of Night*, and *Women without Men*. She now lives in California. Shirin is a graduate student in Biology at Loyola University of Chicago and is presently aiming to become a medical doctor. (Courtesy of the Birjandi family.)

Ehsan Eftekhari (at left) sits with Ahmad Shamlu, his mother, Ameneh Eftekhari, and Mrs. Safarzadeh, *c*. 1990. Mr. Eftekhari is now an injury lawyer, working in downtown Chicago. (Courtesy of the Akbari Family.)

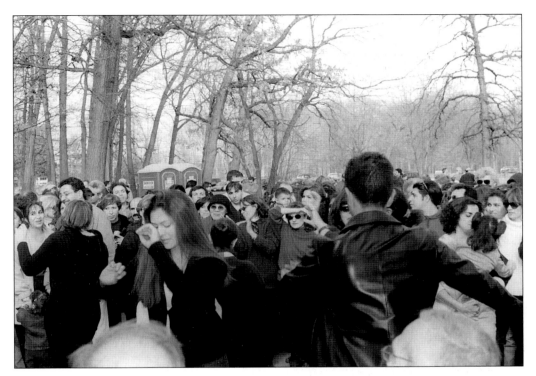

Iranian youth born and raised in Chicago have fully embraced their community and their Iranian heritage. Here they are shown dancing at recent events sponsored by the Iran House of Greater Chicago. (Courtesy of the Iran House of Greater Chicago.)

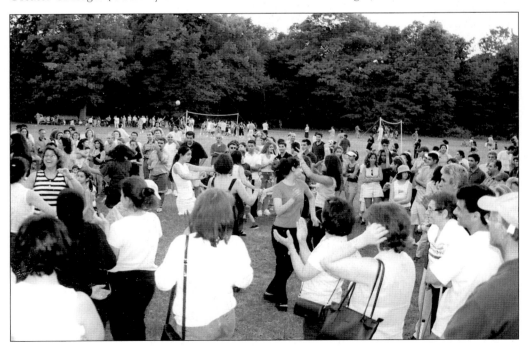

Shirin Vossoughi is studying for a law degree at New York University. She traveled to Chicago to give a talk on the historiography of Iran at the Iran–Guatemala Conference on the campus of Northeastern Illinois University in November 2003. Her father, Mr. Vossoughi, accompanied her; he was witness to the events leading to the coup of 1953, while his daughter reflected on them. Their shared perspectives were most resourceful and emotional. (Courtesy of Ario.)

Shopy (Shaparak) Khorsandi came to Chicago from London to present at the Iranian Cultural Society's annual Mother and Daughter Luncheon in 1998. A stand-up comedian, she is daughter of Iran's satirical writer, Hadi Khorsandi. (Image by Amir Noormandi. Courtesy of d'Last Studios.)

Two generations of Iranians are honored as meritorious citizens during the 1996 Nowrouz Festival of Life. Pictured, from left to right, are: Ronak Rais Dana (national honor roll for piano), Ghoncheh Ilkhchi (honor roll for art and music; state track star), Kevin Kordi (gold medalist for piano, central USA), Hootan Bahmandeji (first Iranian Sergeant in the Chicago Police Department), and Edwin Amir, first Iranian holder of a Purple Heart medal. Not pictured is M.T. Takhtechian, M.D., honored for more than two decades of public service. (Image by Amir Noormandi. Courtesy of d'Last Studios.)

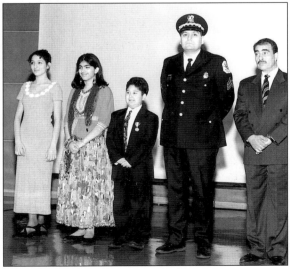

The late Dr. Mahmoud Hashemi presents an educational certificate to a student of the Pars Educational and Cultural Society c. 1986. (Courtesy of Shahla Afshar.)

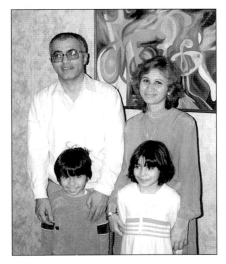

The first generation born in Chicago is now a working generation. Ahmad Neyestani first came here as a student and later became a math instructor at the YMCA on Wabash Avenue; he is pictured here in the late 1970s with his wife, Azam, and their children, Ali (left) and Zahra. Ali has graduated from UIC and is now a computer systems expert. Zahra also graduated from UIC in English and works downtown. (Courtesy of the Birjandi Family.)

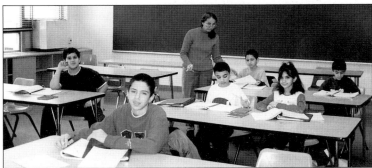

Shown at right is the future generation of Iranian Americans at the Persian School at the Iran House of Greater Chicago. (Courtesy of the Iran House of Greater Chicago)

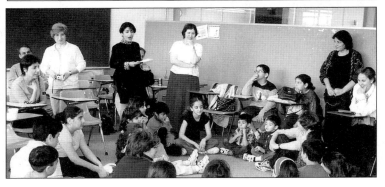

Dr. Sohaey is shown here with his daughter, Roya, the next generation M.D. in the family, c. 1988. (Courtesy of the Sohaey Family.)

Pictured here are Dr. Rahmat Pirnazar, M.D. and his son Ramin (another M.D.) at Ramin's graduation ceremony. (Courtesy of the Pirnazar Family.)

Omid Oskoui, an economics student at the University of Chicago, and his father, a longtime activist, stand side by side during the Iran and Guatemala Conference in 1992. (Courtesy of Ario.)

This 2004 photograph shows Shab Jomeh participants. Neda Nabavi (third from the left) is the Chicago chapter founder and coordinator. (Courtesy of Neda Nabavi.)

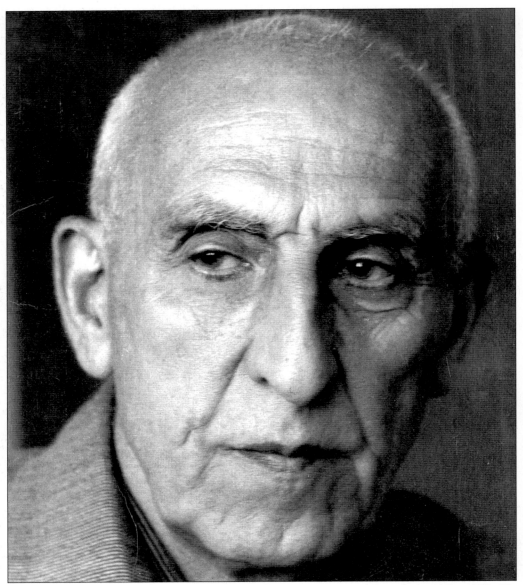

Dr. Mohammad Mossadegh (1882–1967) was prime minister of Iran from 1951–1953. He successfully led the oil nationalization movement in Iran and was named the *Time Magazine* Man of the Year in 1951. All royalties received from this book will be donated to the Dr. Mohammad Mossadegh Leadership Fund at Northeastern Illinois University in Chicago, Illinois. This fund will provide scholarships to one or more students at Northeastern each year and will sponsor annual lectures on democracy.